RODIN

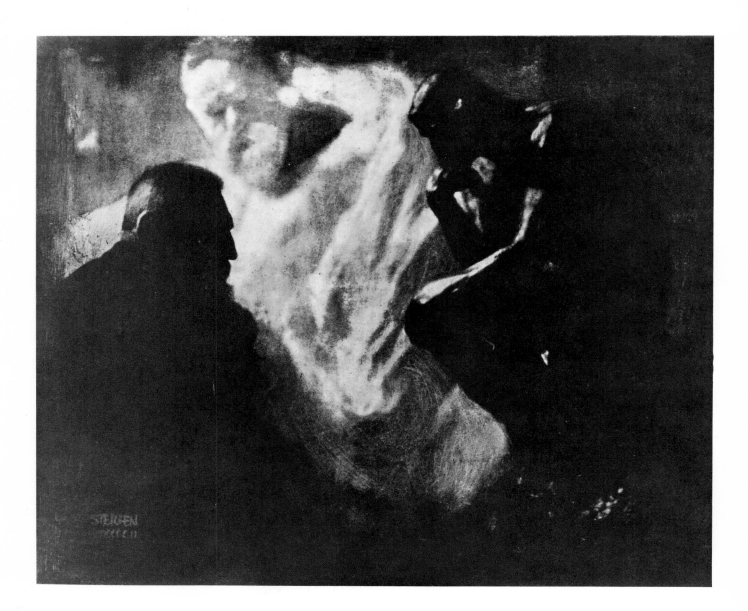

RODIN

by

RAINER MARIA RILKE

TRANSLATED BY ROBERT FIRMAGE

➔

Peregrine Smith, Inc.

SALT LAKE CITY

1979

Copyright © 1979 by Peregrine Smith, Inc.

All rights reserved. No part of this book may be used or reproduced by any means without written permission from the publisher.

Library of Congress Cataloging in Publication Data

Rilke, Rainer Maria, 1875–1926.
Rodin.

Translation of Auguste Rodin.
1. Rodin, Auguste, 1840–1917.
NB553.R7R65 1979 730'.92'4 79-19242
ISBN 0-87905-055-1

Book design by Richard A. Firmage.

Cover photographs by Edward Steichen; courtesy of Princeton Art Museum.

First printing.

Manufactured in the United States of America.

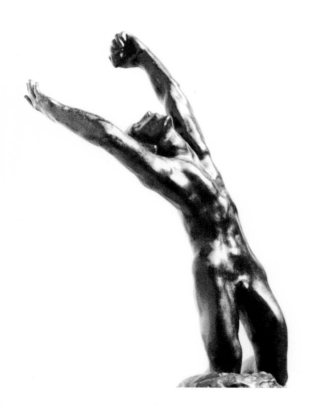

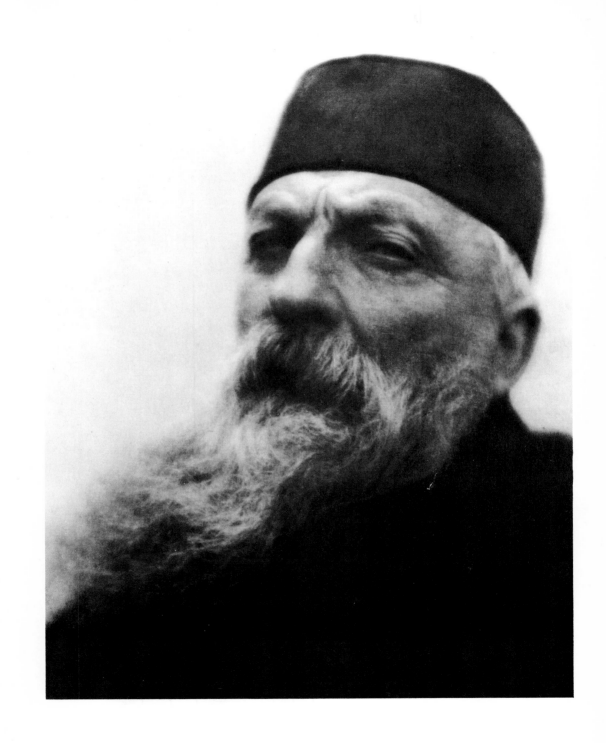

INTRODUCTION

In 1902, when Rilke first met him, Rodin was 61 years old and at the height of his powers, internationally acclaimed, without doubt the most notorious sculptor of his day. His work had been exhibited many times in France and abroad, notably in Belgium and Holland in 1889, in Geneva and Venice, in London and Chicago; and most importantly, at the Exposition Universelle in Paris in 1900, the first large-scale retrospective of his work, which had proved an immense critical and financial success. His works had been purchased by public subscription in London and Prague, and by private collectors throughout Europe and the Americas. He had been honored countless times, both publicly and privately, and in 1893 was elected president of the sculpture section of the National Society of Fine Arts.

But in large measure his fame had also spread due to his involvement in several more scandalous affairs. In 1877 the excellence of The Age of Bronze *had taken the judges at the Salon so by surprise that they could only moot the suspicion that it had been cast from nature. In 1880 he received a commission for* The Gates of Hell, *intended for installation at the Museum of Decorative Arts, which he promised to finish by 1884, but in fact never completed, much to the displeasure of the Committee of Fine Arts. Rodin continued to work on this project his entire life, albeit with decreasing vigor and direction after the 1880s, but was never entirely satisfied with his solutions to the problems it posed. His quandary was made easier by the government's abandonment of the plan to build a separate edifice for the Museum, and at the turn of the century he refunded the advances given him on his commission. Thus* The Gates of Hell *came to serve as a personal expression of his artistic career, an emblem of his titanic aspirations, his immense achievement, and—in the eyes of the public—his inability to complete the projects entrusted to him.*

His reputation as artiste maudit *was exacerbated by two other scandals commencing at this time. In 1884 he was awarded a commission by the city of Calais to erect a monument to the heroes of the siege of 1347. Although the committee desired that only one figure, that of Eustache de St. Pierre, be portrayed, he offered to give them six for the price of one, and good Burghers themselves, they consented. But when the group was finally unveiled, nine years late, in 1895, they were dismayed not only at its seeming lack of composition, but also at the anti-heroic attitude of the individual Burghers, who in expressing Rodin's conception of human greatness in suffering, failed completely to express the conventional gestures of stoic impassivity so desired by the city fathers. In retaliation they refused Rodin the site in the marketplace that he desired, not relenting until nine years after his death. In the ensuing charges and countercharges, controversy over the merits of the monument raged across Europe; but this was as nothing compared to the furor aroused by the monument to Balzac.*

Rodin received the commission for this monument in 1891 from the Société de Gens de Lettres at the instigation of its president, Emile Zola. Rodin at first promised to complete the work in eighteen months, but it was not until 1898 that the final plaster version was unveiled, only then to be rejected both as an unfinished sketch and as a revolting caricature of the writer. In the public uproar that followed, Rodin withdrew the work from the Salon and refused to have it cast during his lifetime. He seems to have regarded it as his most important work, the summation of an entire lifetime of struggle with aesthetic problems, and was startled by the intensity of the antagonism that it aroused in the press and the public. It was widely lampooned, and the resulting scandal overshadowed for a time even the Dreyfuss affair in the popular imagination. Rodin himself was vilified as a charlatan or an aberrant genius, and never again attempted a work on such a large scale. The monument was not without its ardent supporters, but to this day controversy continues as to its relative success or failure. It is seen either as the culmination of nineteenth century sculpture or as an emblem of the malaise afflicting the modern artist. Perhaps the only thing about it not disputed is that it represents a step beyond what had hitherto passed for monumental art.

But it was not only Rodin's work that aroused public indignation. In 1886 his Idyll was refused by the Royal Academy in London, a decision which was justified in part by calling him the "Zola of sculpture" and referring to the coarseness and the erotic mania of his imagination. Here even Robert Louis Stevenson came to the defense of the sculptor, admitting that Zola's "diseased ideals" were destructive of true art, but claiming that Rodin was not such a "realist," that his work was a "noble expression of noble sentiment and thought." Nevertheless, the eroticism inherent in his work was not to be gainsaid, producing no end of opposition in more "Victorian" sensibilities in England, France and elsewhere. This was only compounded by the notoriety of his personal life; not only was his thirty-years liaison with Rose Beuret the object of much offense, but his relationship with Camille Claudel was likewise well-known, achieving for him the reputation of a "Satyr," whose sculpture merely attested to the debased sensuality of his life-style.

Thus Rodin's position in 1902 was of a curiously paradoxical nature; on the one hand, secure in an international reputation and the fervid admiration of hundreds of critics, artists and connoisseurs of art; on the other hand, condemned for prurience and chicanery by large numbers of the press, the public and the more conservative elements of the art establishment. To explain this situation became one of Rilke's major concerns as he set forth to confront and to introduce the immensity and grandeur of the "master's" work.

Rilke seems to have become intensely interested in Rodin in 1900, under the influence of Clara Westoff, whom he was to marry in 1901, and who had formerly been a student of Rodin. At this time the poet was undergoing a two-fold crisis in his poetry and his daily life. He had begun to feel that his poetry was not progressing as he wished, and had grown suspicious of his method of composing only under "inspiration," where he would often write an entire volume in a fortnight after long months of despairing silence. He felt that he needed more education and more free time, while the possibilities for both diminished catastrophically with the birth of his daughter in late 1901, and with his father's decision to discontinue, in the summer of 1902, the allowance which had been his economic mainstay. By June of that year he and Clara had resolved that he must go to Paris to study in the libraries and possibly to meet Rodin, while Clara would resume her work in sculpture and little Ruth would be given over to the care of her maternal grandmother. By July this plan was settled when Rilke obtained a commission from Richard Muther, an art critic and editor who had come to know Rilke through the latter's efforts at journalistic breadwinning, to write a monograph on Rodin for Muther's series Die Kunst, published in Berlin. On August 1 Rilke wrote Rodin an introductory letter in which he portrayed himself more as a disciple than as a critic, as a young artist seeking a master and an example. On September 1, at the age of 26, he arrived at Meudon, where Rodin welcomed him with great hospitality and charm, allowing him many hours of inspection, contemplation and discussion for the next six months. The monograph (which comprises the first part of the present volume) was completed in December 1902 and published in March 1903. In it Rilke relied primarily on hints given him by his new mentor: the importance of gothic cathedral sculpture (his knowledge of which was supplemented by intensive research at the Bibliotheque Nationale), the priority of modeling, the primacy of surface, and the artist's perpetual quest for life; but feeling himself a disciple, he subordinated these insights to the two great truths he found most relevant to his own development: the necessity of work ("il faut travailler") and the concept of the thing. These became his own guiding principles for the next ten years, supplanting the vatic orientation of his earlier work. The artist is he whose genius is incessant labor to achieve a thing which is self-contained, concentrated and independent of the world of accident: a doctrine culminating in the celebrated "thing-poems" of his Neue Gedichte and in the existential crises of The Notebooks of Malte Laurids Brigge.

By March 1903 Rilke had had as much of the squalor of Paris as his sensibility would allow, and embarked on a two-year's sojourn through Italy, Denmark and Germany before

he felt himself ready to return. In the meantime Rodin had received the monograph, had it translated at his own expense, and seems to have been gratified by its insights and homage. As Rilke relates in a letter to Clara: "He said the greatest that can be said; he has placed it beside his things..."

In September 1905, hearing that Rilke wished to return to Paris, Rodin invited him to stay at Meudon in the capacity of his private secretary, a post which was supposed to occupy only two or three hours of the poet's day. Delighted, Rilke accepted, but his responsibilities were greater than had been foreseen, often extending from morning to night, and compounded by the sculptor's moodiness and irascibility. On top of this, Rilke was attempting to complete work of his own, and when in May 1906 a misunderstanding arose when Rilke took it upon himself to answer two of Rodin's acquaintances without first consulting the master, he was dismissed "like a pilfering servant," probably to the secret relief of both. In his letter to Rodin on this occasion, Rilke displays no animosity, continuing to address him as "mon maitre," explaining the correspondence as being concerned only with matters relating to himself, and concluding with the declaration:

> *I am convinced that there is no man of my age (neither in France nor anywhere else) who is as endowed as I (by his temperament and by his work) to understand you, to understand your great life, and to admire it so conscientiously.*

Already in October 1905 Rilke had acted on this conviction by lecturing on the sculptor in Dresden and Prague, and again in March 1906 in Berlin, Hamburg, Bremen and Weimar. When in 1907 a third edition of the monograph was called for, this lecture was included as the second part, transcribed "as it was spoken, but incremented by more than half." Rilke worked on the text in June and July of 1907, deciding to keep it in its original character, without reference or regard to what had been discussed in the first part. This may produce a feeling of vertigo in the reader, who having just finished fifty pages extolling Rodin, is suddenly asked to forget his name; but it is at least partially justified by Rilke in the introduction which originally accompanied the second part.

> *Since the thoughts appearing in this context are still valid, the original form of their utterance may not be taken from them; it is the most natural form. For not merely in their employment, but also in their nature, there lies something of a lecture; they want to be heard. They want to speak truly, to many people; they want to attempt to mediate between this and that life and a great art.*

Thus the two "parts" of the present work are intended to stand as complementary wholes, related mainly by the life and the work with which they deal. They represent two approaches to this art, separated by the span of three years, and reflecting the poet's developing comprehension of its significance. In both parts the poet is adulatory, as though overwhelmed by the majesty of the subject that confronts him; in both parts the "master" appears almost superhuman, nearly free of faults and foibles: his well-documented temper and procrastination are never mentioned, and even the extralegality of his relationship with

Rose Beuret is glossed over. His art also seems faultless: his treatment of the composition of The Burghers of Calais *is triumphant rather than problematic, and even Rodin's own doubts about* Balzac *are not recounted. Rilke himself relates that many people had told him that his book was beautiful, but it was not Rodin. And yet the same high tone of praise remains constant throughout both parts, as though the poet felt that only from such complete subjugation to its excellence could the true significance of the work be understood. Such adulation often works against the credibility of his judgments; but even more fulsome praise could not detract from the geniality of his treatment of surface, gesture and thing, nor from the lyric splendor of his descriptions of individual pieces and the justice of his discussions of the relationship of work and art.*

Yet there are also differences between the two parts. Especially in the second we get a clearer view of the master, and of the significance of his life and work. Rilke had matured; his Neue Gedichte *had given him new confidence, and an extended relationship with Rodin had given him a deeper understanding of the sculptor's place in the art of his day. There are passages in the second part which seem to come from the sources of the* Neue Gedichte, *so that both works are amplified, where we find a fertility in the intercourse of poetry and sculpture perhaps unequalled in the history of art. Though the eulogistic tone remains constant, the triumph no longer belongs solely to the sculptor, the poet has come to share in it.*

Despite the fiasco involving the correspondence, Rodin's reception of the second monograph seems to have been even more enthusiastic than of the first, delighting in its "beauty" and its "truth." Their relationship remained cordial until 1913, but seems to have deteriorated from then to Rodin's death in 1917, partly due to the sculptor's growing senescence and partly to conditions imposed by the war. Nevertheless, Rilke never ceased to consider Rodin his master, nor to think of him without admiration and gratitude.

As to the monograph, perhaps the most just criticsm of it was provided by the poet himself in a letter to his Polish translator, Witold von Hulewicz, dated December 14, 1922.

> *For a real and valid appraisal of Rodin and his work, what I wrote twenty years ago... will not be a very essential contribution. Aside from my all too youthful attitude, I lacked distance, and the entire nature of my proximity to the master was one-sided, wholly determined by whatever was necessary and helpful for me to learn from him. If I were to write today of that great work and of its creator, admiration—the wish and the obligation to admire—would certainly still be the means and the measure of my conception; but how much harder would this admiration be today, in view of the disasters by which (seen from a greater distance) Rodin's own being and his rebellious achievement were oppressed and finally overpowered. But what even now assures, in my view, a kind of justification to my notes is...their human devotion to the great example, their conviction that to bring forth art is a calling most simple and severe, but at the same time a destiny, and thus greater than any of us, more powerful, and immeasurable to the end.*

Robert Firmage

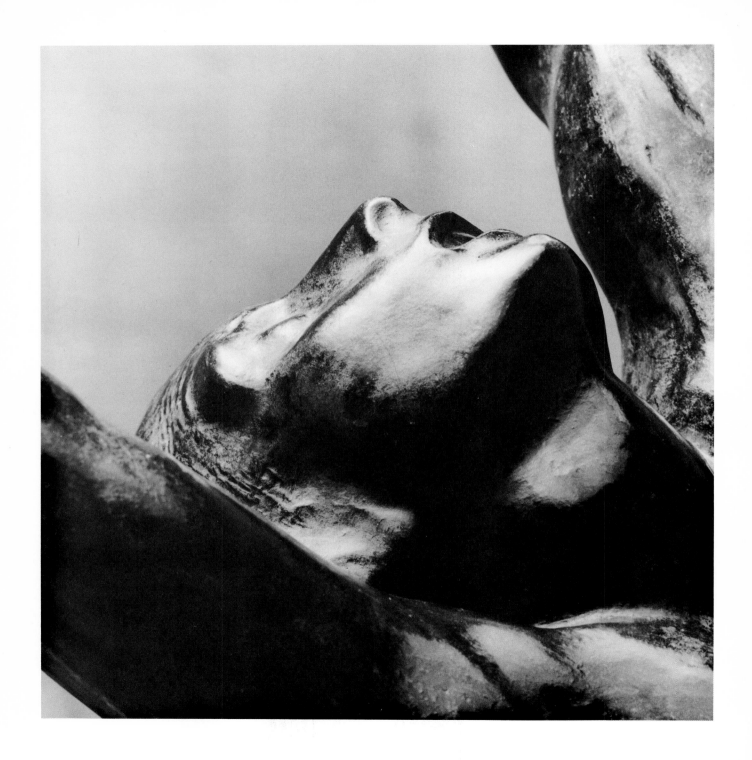

RODIN

Writers act through words,
Sculptors through deeds.

POMPONIUS GAURICUS
De Sculptura (c. 1504)

The hero is he who is immovably centred.

EMERSON

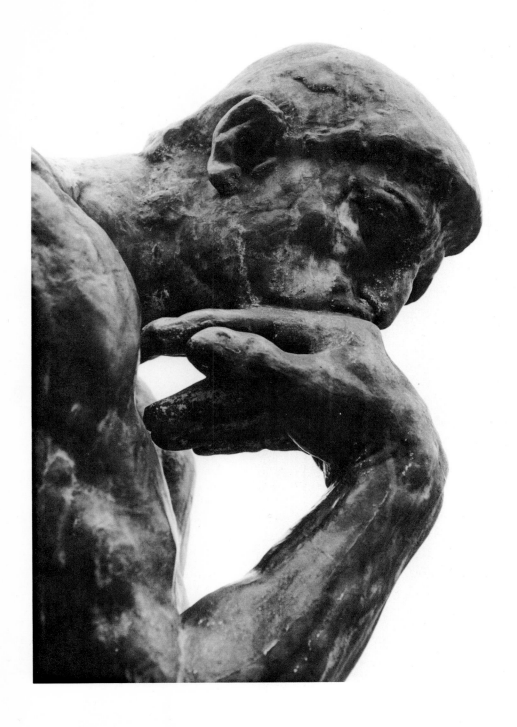

14

FIRST PART

Rodin was solitary before his fame. And fame, when it came, made him perhaps even more solitary. For in the end, fame is nothing but a constellation of all the misunderstandings that have gathered about a new name.

There are many of these concerning Rodin, and it would be a long and arduous process to eliminate them all. But that is not necessary: they concern the name, and not the work, which has grown far beyond the sound and limits of the name, becoming nameless, even as a plain is nameless, or a sea, which has a name only upon a map, in books and among people, but in reality is only expanse, movement and depth.

This work, of which we are to speak, has grown for many years, and grows each day, and does not lose an hour. One passes among its thousand things, overpowered by the fullness of invention and discovery that it encompasses; and one looks about instinctively for the two hands from which this world has sprung. One remembers how small human hands are, how quickly they get tired, and how little time is granted them for their activity. And one longs to see these hands, which have lived like a hundred hands, like a tribe of hands, which arose before sunrise to set forth on the long pathway of this work. One wonders about the man who is the master of these hands. Who is this man?

He is old. And his life is one of those that cannot be recounted. This life began and it passes, it passes far into a great age, and for us it is as if it has been past for several hundred years. We know nothing of it. It will have had a childhood, a childhood of some sort; in poverty: dark, searching and uncertain. And perhaps it still has this childhood, for—as Saint Augustine once said—where should it have gone? Perhaps it

still has all of its past hours: hours of waiting and abandonment, hours of doubt and long hours of need; it is a life that has lost or forgotten nothing, a life that has gathered itself in as it was passing.

Perhaps; we know nothing of it. But only from such a life, we believe, could the fullness and overflow of such activity proceed; only such a life, in which everything is contemporaneous and awake and nothing is past, could remain young and strong and ascend ever further to exalted works. Perhaps there shall come a time when someone will devise a history for this life, with all of its complications, its episodes and details. They shall all be devised. We shall hear about a child who often forgot to eat, because it seemed more important to him to carve things in bits of wood with a dull knife; and some sort of encounter will be placed in the days of his youth, containing a promise of future greatness, one of those prophecies after the fact that are so prominent in folk-lore, and so touching.

It could just as well be the words that a certain monk is said to have repeated to young Michel Colombe almost five hundred years ago, these words: "Travaille, petit, regarde tout ton saoul et le clocher à jour de Saint-Pol, et les belles oeuvres des compaignons, regarde, aime le bon Dieu, et tu auras la grâce des grandes choses."
—And thou shalt have the grace of great things. Perhaps an inner feeling had so spoken, endlessly more quiet than the monk's voice, to the youth at one of his crossroads in his early days. For it was precisely this he sought: the grace of great things.

There was the Louvre with its many lucid objects from antiquity, recalling southern skies and the proximity of oceans; and behind these there rose other things, heavy stone things from unthinkable cultures lasting onward into times not yet come. There were stones that slept, of which one felt that they would first awaken on some Day of Judgement: stones about which there was nothing mortal, and yet others which bodied a movement, a gesture, which had remained so fresh that it seemed that it was merely being stored there to be given some day to a child as he passed by. And such vitality was not only to be found in the famous and most visible works; the small and the unnoticed, the nameless and the numberless were no less filled with this deep and inward excitation, with this rich, astounding unrest of the living. Even stillness, wherever there was stillness, was composed of hundreds and hundreds of moments of motion counterbalancing one another.

There were small figures there, animals especially, that moved or stretched or crouched; and when a bird perched, then one knew it was a bird, for a sky grew out of it and hovered about it, distance was folded up and inlaid onto each of its feathers, that it could be spread out again and made vast. And it was the same with the animals that stood or sat on the cathedrals, or cowered under the consoles, wretched and crooked and too sluggish to bear anything. There were dogs and squirrels, woodpeckers and lizards, turtles, rats and snakes. At least one of every kind. These animals seemed to have

been trapped outside in the forests and along the roadsides, and it was the constraint of living among stone tendrils, leaves and blossoms that must have gradually transformed them into what they now were and would always remain.

But there were also animals to be found there that had been born in these petrified surroundings, without recollection of another existence. Already they were wholly the inhabitants of this upright, towering, precipitously rising world. Beneath their fanatical emaciation were the skeletons of gothic arches. Their mouths were opened wide and skrieking, like the deaf, for the nearness of the bells had destroyed their hearing. They were not able to bear anything, but they stretched, and thereby helped the stones to rise. The birdlike squatted high up on the balustrade, as though they were actually underway, and merely wished to rest there for a couple of centuries, gazing down upon the growing city. Others, who had descended from dogs, thrust themselves horizontally from the lip of the gutters into the air, ready to spew the rainwater from their jowls, already swollen with spitting. All of them had adapted or had been transformed, but had lost nothing of life. On the contrary, they lived more intensely and vehemently, lived eternally the fervid and boisterous life of that time which had given them existence.

And whoever saw these figures sensed that they had not been born out of caprice, not out of some playful attempt to discover new, unheard-of forms. Need had created them. Out of dread of the invisible judgments of a ponderous faith men saved themselves through what was visible; out of their uncertainty men fled to this embodiment. They still sought their reality in God, but no longer by means of inventing pictures of Him and attempting thus to image forth the All-too-remote. One showed devotion in so far as one had borne all dread and poverty, all fearfulness and all the gestures of humility into His house, and placed them in His hand, and laid them on His heart. That was better than painting. For even painting was a deception, a beautiful and skillful fraud, and they longed for something more real and simple. Thus arose the curious sculpture of the cathedrals, this crusade of the animals and the heavy-laden.

And when one looked back from the plastic art of the middle ages into antiquity, and again beyond antiquity to the beginning of unspeakable times, didn't it seem at every bright or dreadful turning-point as though the human soul had always longed for this art, which gives more than word and image, more than imitation and appearance, for this simple turning-to-a-thing of its desire and fear? The last great age of plastic art had been the Renaissance, at a time when life had been renewed, when men had discovered the mystery of faces and the great gestures that are found in growth.

And now? Had a time not come again that cried out for such expression, for such stark and penetrating exposition of all that was unspeakable, confused and enigmatic in it? The arts had somehow been renewed; zeal and expectation filled and vitalized them. But was it perhaps just this art, sculpture, still lingering in the fear of a mighty past, which would be called to discover what the others groped and yearned for? It must be

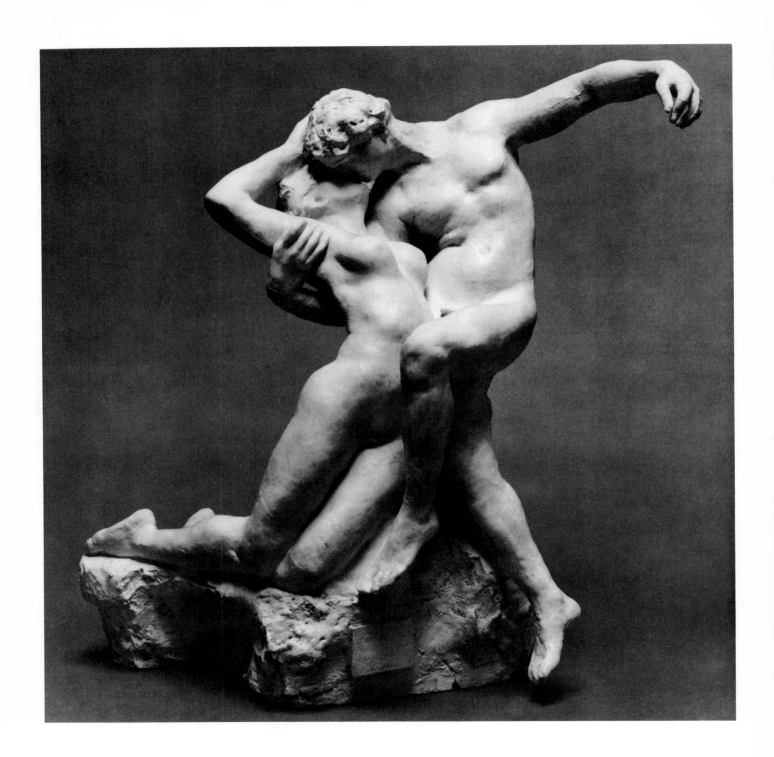

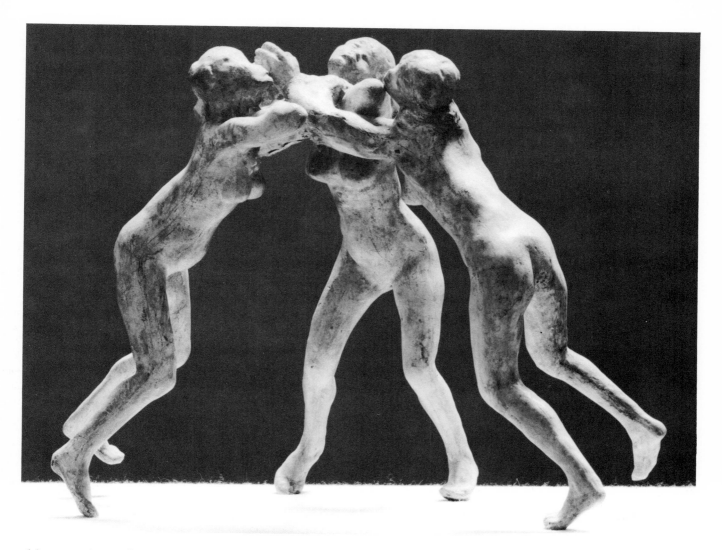

able to assist such a time, tormented by conflicts occurring almost exclusively in the invisible. Its language was the body. And the body—when had anyone last seen it? Garments had covered it, layer by layer, like a continually renewed veneer; but beneath the shelter of this encrustation, the growing soul had changed it, even as it labored breathlessly on the faces. It had been transformed. If someone could now unveil it, perhaps it would contain a thousand expressions for everything nameless and new that had come about in the meantime, and for those ancient mysteries which, risen from unconsciousness, lift their dripping faces like strange river gods out of the torrent of the blood.

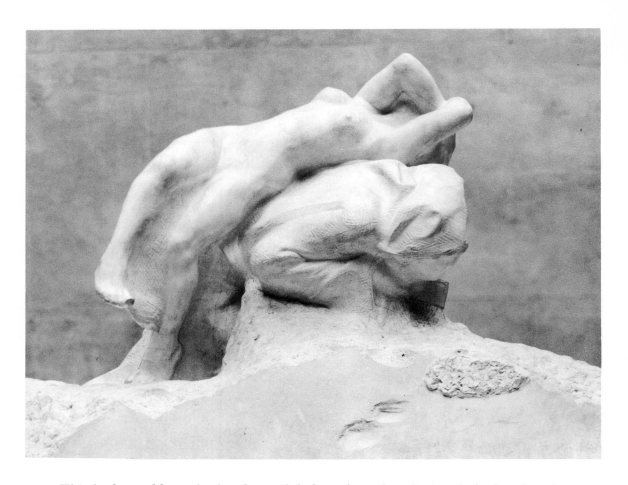

This body could not be less beautiful than that of antiquity. It had to be of even greater beauty. Life had held it in its hands two thousand years longer, and worked on it, listening and hammering day and night. Painting dreamed of this body. It had bedizened it with radiance and steeped it in twilight; it had enclosed it in all tenderness and transport; had caressed it like a flower-petal and was borne upon it as upon a wave. But sculpture, to which it belonged, didn't know it yet.

Here was a task as immense as the world. And he who stood before it and perceived it was an unknown whose hands groped for their bread in darkness. He was completely alone, and had he been a proper dreamer, he should have dreamed a deep and lovely dream that no one would have understood: one of those long, long dreams, across which a lifetime can stretch like a single day. But this young man, who earned his living in the factories of Sèvres, was a dreamer whose dream rose up into his hands; and he began at once to make it true.

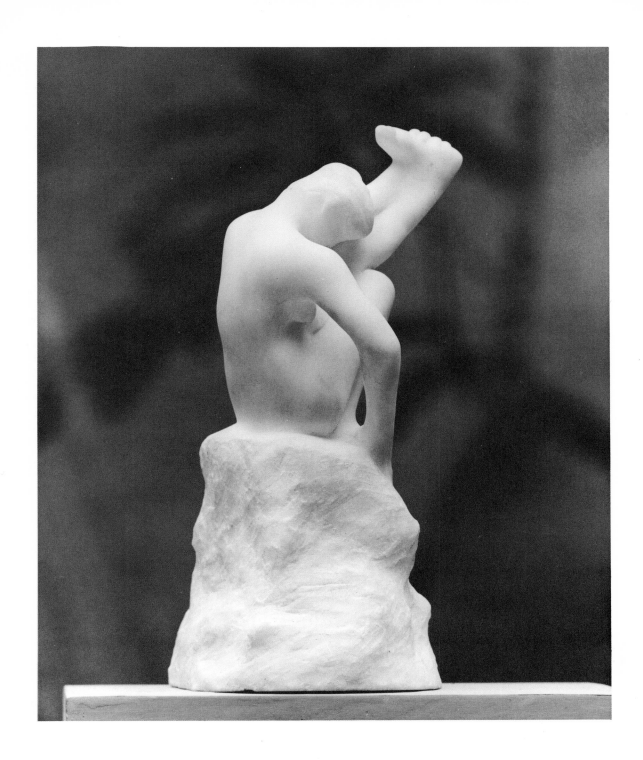

He sensed where he must start; a peace within him showed him the correct way. Here already was revealed Rodin's deep accord with nature, of which the poet Georges Rodenbach has spoken so beautifully, calling him simply a natural force. And indeed, within Rodin there is a dark perseverence which makes him almost nameless; a still, superior patience: something of the great goodness and perseverence of nature, which begins with nothing to proceed in earnest stillness its long pathway to abundance. Rodin too did not presume to begin by making trees. He began, as it were, with the seed beneath the earth. And this seed grew downward, sinking root after root below, anchoring itself before it made its first tiny thrust upward. That took time; much time. "One musn't hurry," said Rodin to his few close friends when they urged him on.

Then came the war, and Rodin went to Brussels and worked there as the day afforded. He executed several figures for private houses and many groups on the exchange buildings, and created the four large corner figures on the monument to Mayor Loos in the park at Anvers. These were commissions which he carried out conscientiously, without allowing his developing personality to come to expression. His actual development took place on the side, compressed into pauses and in the evening hours, extended in the solitary stillness of the nights; and for many years he had to bear this fragmentation of his energies. He possessed the power of one for whom a great work is waiting, the silent endurance of them who are necessary.

While he was working on the Brussels Exchange, he may have sensed that there were no longer buildings which collected works of sculpture about themselves as had the cathedrals—those great magnets of the plastic art of a vanished time. Now the work of sculpture was alone, as the easel-painting was also alone, but unlike the latter, it didn't need a wall. Nor even a roof. It was a thing that could exist on its own, and it was good fully to give it the nature of a thing, so that men could walk around it and study it from every side. And yet it must somehow be distinguished from the other things, the familiar things, which anyone could grasp hold of. Somehow it must become untouchable, sacrosanct, isolated from chance and from time, in which it rises, solitary and wonderful as the face of a clairvoyant. It must retain its own sure place, where no caprice had set it, and be introduced into the silent duration of space, and into its great laws. It must be set into the air surrounding it as into a niche, thereby endowing it with a security, stability and exaltation springing simply from its being and not from its significance.

Rodin knew that it was primarily a question of unfailing knowledge of the human body. Exploring gradually, he had progressed outward to its surface, and now a hand stretched forward from without, which defined and limited this surface as precisely from the outer side as from within. The further he advanced upon his isolated way, the further chance was left behind; and one law led him to the next. At last it was the surface to which his exploration turned. It consisted of infinitely many encounters of light with a

thing, and it was apparent that each of these encounters was different, and each remarkable. At one place they seemed to absorb one another, at the next to greet each other hesitantly, at a third to pass each other by like strangers. There were places without end, and no place where nothing happened. There were no voids.

At this moment Rodin had discovered the fundamental element of his art, what amounted to the cell of his world. This was the surface, this variously extensive, variously accented, precisely delineated surface, out of which everything was to be made. From this time on, this was the subject of his art, on which all of his effort was expended, that for which he watched and suffered. His art was not based upon a great idea, but on small and conscientious realizations of what was achievable, upon a craft. There was no arrogance in him. He gave himself to this unseemly and difficult beauty, which he was able to survey, call forth and judge. That other, greater beauty must come when everything was ready, as animals come to drink when night has ended and nothing strange still lingers in the forest.

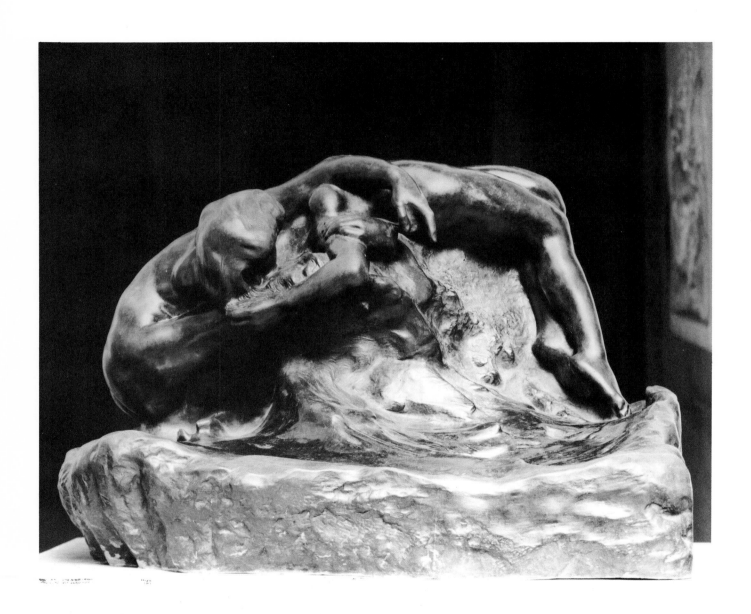

With this discovery, Rodin's actual work began. For him all the inherited concepts of sculpture had become worthless. There was neither pose, nor group, nor composition. There were only innumerably many living surfaces. There was only life; and the means of expression that he had discovered led directly to this life. Now it was up to him to take command of it and of its fullness. Rodin caught hold of life, which, wherever he looked, was everywhere about him. He caught it in the smallest places; he observed it and pursued it. He lay in wait for it at the transitions where it hesitated; he overtook it in its flight; and in every place he found it equally great, equally powerful and enchanting. There was no part of the body meaningless or insignificant: it lived.

Life, which was as prominent in faces as on the dial of a clock, as easily read and as full of reference to time, was more attenuated in bodies, greater, more mysterious, more eternal. Here it did not disguise itself; here it passed carelessly where there was carelessness and proudly among the proud. Exiting from the stage of the face, it had removed its mask, and stood as it was behind the wings of its clothing. Here he found the world of his time, just as he had recognized that of the middle ages in the cathedrals: gathered about a mysterious darkness, held together by an organism to which it was adapted and which it was made to serve. Man had become a church, and there were thousands and thousands of churches, none like another and every one living. But it was necessary to show that they were all of the same God.

Year after year Rodin pursued the ways of this life as a learner, a supplicant, feeling himself a beginner. No one knew of his efforts; he had no confidants and few friends. His developing work was concealed behind the labor that fed him, waiting its own time. He read much. It was usual to see him in the streets of Brussels with a book in his hand; but maybe the book was only a pretext for his immersion in himself and in the immense task that stood before him. Like all men of action, he felt that he had unforeseeable work to accomplish, he felt a driving force within him that intensified and concentrated his powers. And when he was visited by doubt or uncertainty, by the great impatience of becoming, the fear of a premature death or the threat of daily need—all this found in him a still, upright resistance, a defiance, strength and confidence: all the yet unfurled banners of great victory.

Perhaps it was the past that stepped up to his side in such moments, the voice of the cathedrals, which he repeatedly went to hear. But much that supported him came from books as well. He read Dante's Divine Comedy for the first time. It was a revelation. He saw before him the suffering bodies of another generation; saw, across all intervening days, a century from which the garments had been stripped, saw the great and unforgettable judgment of a poet on his own time. There he found images that vindicated him; and when he read of the weeping feet of Nicholas the Third, he had already known that there are feet that weep, that there is a weeping which is everywhere, a weeping of the entire person, and tears that seep from every pore.

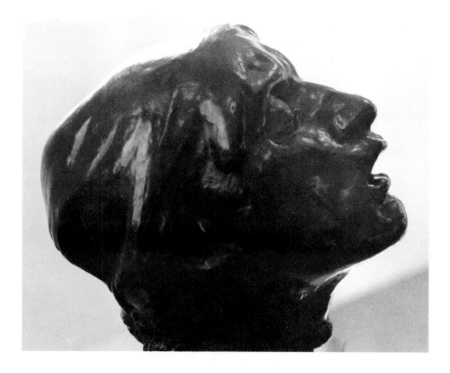

From Dante he came to Baudelaire. Here there was no judgment, no poet climbing into heaven at the hand of a shadow. A man, one among the wretched, had raised his voice and held it high above the heads of the others, as if to save them from destruction. In these verses there were passages that leapt out from the page, passages that did not seem written, but sculpted; words and groups of words that had been smelted in the poet's burning hands; lines with the texture of a relief and sonnets bearing the burden of a fearful thought like columns with labyrinthine capitals. Darkly he began to sense that where this art abruptly stopped it thrust on the beginning of another, and that it had yearned for this other art. He sensed in Baudelaire one who had gone before him, who had not been led astray by faces, but sought bodies, in which life was greater, crueler and more restless.

From those days on, these two poets remained close to him; his thought went constantly beyond them and then returned again. In that time, when his art was being molded and prepared, when all the life it learned was nameless and without meaning, Rodin's thought wandered through the poets' books and found itself a past. Later, when as a creator he once again entered this province of material, their forms rose up into him like memories out of his own life, painful and real, and passed into his work as if it were their home.

Finally, after years of solitary labor, he attempted to come out with one of his works. It was a question put to the public. The public answered, negatively. And Rodin then locked himself away again for thirteen years.

These were the years in which, yet an unknown, he ripened into mastery, into unlimited control over his own medium, incessantly working, thinking, probing, uninfluenced by the time, which took no notice of him. Perhaps this circumstance, that his entire development took place in undisturbed stillness, later gave him that powerful self-assurance when men argued about him and opposed his work. Then, when men began to voice their doubts about him, he no longer harbored any doubts about himself. All that lay behind him. His fate no longer depended on the acclamation or the judgment of the multitude; it was already decided when they thought that they could destroy it with enmity and mockery. During the time of his development, no alien voice was raised toward him; no praise that might have led him astray, no blame that might have confused him. As Perceval had grown, so his work also grew in purity, alone within itself, and within a great eternal nature.

Only his work spoke to him. It spoke to him at morning when he awoke, and at evening it resounded long in his hands, like an instrument which one has just laid down. This is why his work was so invincible: because it came into the world mature. No longer something still developing or seeking its justification, it appeared as a reality that had carried itself through, that was there and must be reckoned with. Like a king who, hearing that a city is to be built within his realm, long considers whether it were well advised to grant such a privilege, hesitates, and finally sets out to inspect the site; only to find, when he arrives, that a great and mighty city rises there already completed, rises there with walls and towers and gates as from eternity—so the multitude came, once they were called, to the work of Rodin, which was completed.

This period of his maturation is bracketed by two works. At the beginning stands the head of The Man with the Broken Nose; *at the end, the form of the young man which is called* The Age of Bronze. The Man with the Broken Nose *was rejected by the "Salon" in 1864. And that is easily understood, for one feels that in this work Rodin's manner is already fully developed, fully completed and confident. With the ruthlessness of a great manifesto it sets itself against the claims of academic beauty which then remained solely in force. In vain had Rude bestowed the wild gestures and the gaping cry upon his Goddess of Revolt on the Gate of Triumph at la place de l'Etoile. In vain had Barye created his lithe animals. And the Dance of Carpeaux had merely been ridiculed until everyone had become so familiar with it that he could no longer see it. Everything remained as of old. The sculpture that was promulgated was still one of model, pose and allegory—that easy, approved and comfortable metier, which gets by*

with more or less skillfully executed repetitions of a few sanctioned gestures. In such surroundings even the head of The Man with the Broken Nose would have excited that storm which broke out on the occasion of Rodin's later work. But most likely they sent it back virtually unseen, as the work of an unknown.

One senses what had led Rodin to shape this head, the head of an aging and ugly man, whose broken nose only helps to intensify the tortured expression of his face. It was the fullness of life that was concentrated in these features; it was the fact that there was no symmetrical surface on this face at all, that nothing was repeated and no region remained empty, dumb or indifferent. This face had not been touched by life, it had been afflicted with it, over and over, as though an implacable hand had held it down in fate as in the maelstrom of a rinsing, gnawing water. When one turns this mask in one's hands, one is astonished by the continual shift of profiles, of which not one is accidental, approximate or undefined. There is no line, no overlap or contour on this face that Rodin had not seen and willed. One believes that one can sense which of these furrows came earlier and which later; that between this crease and that, which cross his features, there lie years, frightful years. One feels that some of the marks on this face have been engraved slowly, as if in hesitation; that others were first lightly sketched and then traced deeper by a habit or a thought which came again and again. And one perceives sharp fissures, which must have come in a single night, as though pecked by a bird's beak into the febrile brow of an insomniac.

One must make an effort to remember that all this lies in the breadth of a single face, there is so much ponderous, nameless life that rises up out of this work. Laying the mask down before oneself, one seems to stand upon the parapet of a tower, gazing down upon a ragged land, across whose twisted paths a multitude of tribes have wandered. When one lifts it up again, one holds a thing that must be called beautiful for the sake of its perfection. But this beauty does not result merely from its unexampled accomplishment. It comes from a feeling of equilibrium, of the balancing of all these moving surfaces among themselves, from the perception that all these moments of excitation play themselves out and come to rest within the thing itself. Seized by the many-voiced agony of this face, one feels at once that no complaint comes forth from it. It is not turned toward the world; it seems to bear within itself its own justice, the reconciliation of all its contradictions, and a patience great enough for all its burdens.

When Rodin created this mask, he had a man sitting peacefully before him, a man with a peaceful face. But it was the face of a living man, and as he studied it, it became apparent that it was full of movement, full of unrest and the thrust of waves. There was movement in the disposition of its lines, movement in the inclination of its surfaces; shadows ran across it as in sleep, and light seemed to pass gently by its brow. Nowhere was there rest, not even in death. For through decay, which is also movement, even the dead submit to life.

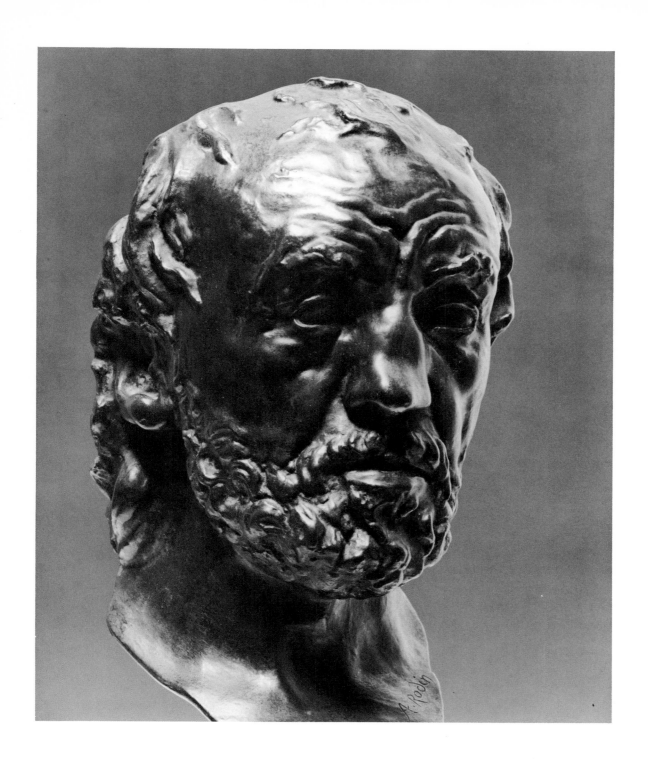

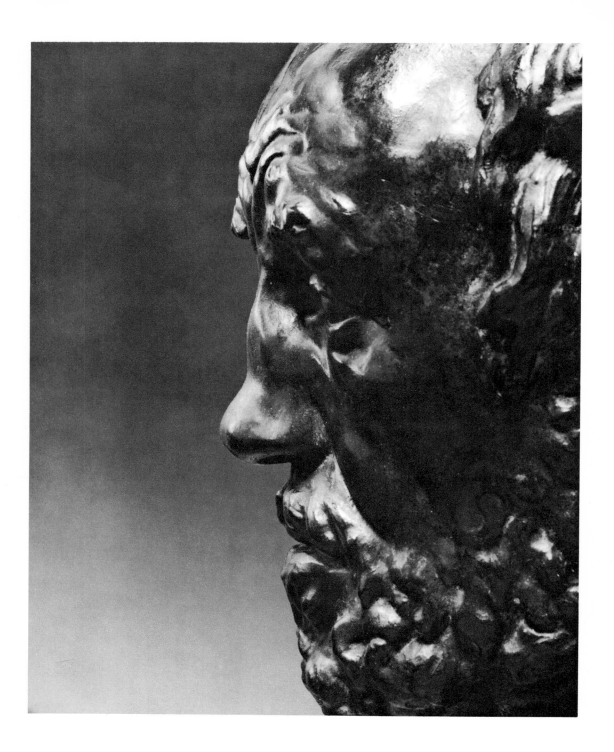

In nature there is only movement; and any art that aspires to bring forth a conscientious and faithful representation of life may not take as its ideal a peace that never existed. In actuality, not even antiquity had known such an ideal. One has only to think of Nike. Not only has this sculpture conveyed to us the movement of a lovely girl running toward her beloved, but it is also an eternal image of the Greek wind, of its vastness and splendor.

Even the stones of ancient cultures were not at rest. The unrest of living surfaces was enclosed within the hieratic, restrained gestures of primordial cults like water in the walls of a vessel. In the withdrawn seated gods there were currents, and in those that stood there was a gesture rising like a fountain from the stone and falling back into it once again, filling it with many waves. For it was not movement that opposed the spirit of sculpture (and that means simply the nature of the thing); it was only movement which did not come to rest, which was not held in equilibrium by other movements, which pressed beyond the boundaries of the thing. A piece of sculpture was like that city of olden times which lived entirely within its own walls. This does not mean that its inhabitants therefore had to hold their breaths; the gestures of their lives were not cut short. But nothing thrust over the borders of the sphere that enclosed them, nothing was beyond them, nothing appeared outside the gates, and there was no expectation turned outward.

However great the movement of a work of sculpture, though it be out of an endless distance, though it be out of the depths of heaven, it must return to that work. The great circle must be closed, the circle of solitude, in which a thing of art passes its days. This was the unwritten law which lived in the sculpture of past ages. Rodin perceived it. This characteristic of things, this being-fully-occupied-with-oneself, was what gave a work of sculpture its peace. It must not expect or desire anything from the outside, must not refer to anything that lay beyond it, nor see anything that was not in it. Its environment must lie within it. It was the sculptor Leonardo who gave the Gioconda her unapproachability, this movement that passes inward, this glance that no eye can catch. His Francesco Sforza was most likely the same; moved by a gesture which returns like a proud ambassador to his own state after a successful mission.

During the long years between the mask of The Man with the Broken Nose *and the figure of* The Age of Bronze *many developments came peacefully to fulfillment in Rodin. New relationships bound him more firmly to past ages of his art. This past and its greatness, which so many had borne like a burden, became for him the wings that bore him on. For during that time, whenever he received corroboration or encouragement in what he sought or desired, it came from the things of antiquity or from the plaited darkness of the cathedrals. People didn't talk to him. Stones spoke.*

The Man with the Broken Nose *had revealed how well Rodin knew his way about a face;* The Age of Bronze *proved his unlimited mastery of the body.* "Souverain tailleur d'ymaiges," *this title by which the earnest and unenvious masters of the middle ages had recognized one another, had become his by right. Here was a life-sized figure on whose every part life was not only equally powerful, but seemed everywhere elevated to the height of the same expression. The same pain of a heavy awakening and the simultaneous longing for this heaviness that was found in the face was also inscribed on the smallest part of this body. Each place was a mouth, speaking it in its own way. The strictest eye could discover no region of the figure that was less living, less definite and clear. It seemed as though strength rose out of the depths of the earth into the arteries of this man. He was the silhouette of a tree, which still anticipates the winds of March, and fears, because the fruit and fullness of its summer dwell no longer in its roots, but have already risen to its trunk, where the great winds shall rage.*

This figure is significant in yet another respect. It represents the birth of gesture in Rodin's work. Gesture, which grew and developed gradually to great magnitude and power, here escapes like a spring, flowing gently downward over this body. It awoke in the darkness of earliest times, and seems, in its awakening, to pass through the breadth of this work as through all millennia, to pass far beyond us to those who shall come. It unfolds itself hesitantly in the arms, arms that are still so heavy that the hand of one is resting again at the top of the head. But it is no longer sleeping; it is gathering itself, high on the peak of the brain, where there is solitude. It prepares for its labor, the labor of the centuries, which has neither purpose nor end. And in the right foot a first step stands waiting.

One could say of this gesture that it is resting as if enclosed in a young bud. The fire of a thought and a storm in the will: it shall open. And out of it shall arise that St. John the Baptist *with the speaking, agitated arms and the giant stride of one who feels another coming after him. The body of this man is no longer unproven: the wilderness has enkindled it, hunger has afflicted it, and every thirst has given it its test. He has endured and become hard. His emaciated ascetic's body is like a wooden handle in which the wide fork of his stride is set. He walks. He walks as if all the expanses of the world were within him, and he were dispersing them with his stride. He walks. His arms speak of his passage and his fingers are spanned wide and seem to make a sign of striding in the air.*

This St. John the Baptist *is the first walking figure in Rodin's work. Many follow. Soon the* Burghers of Calais *begin their heavy tread, and every walking seems to prepare for the great and challenging step of* Balzac.

But the gesture of the standing figure is also developed further; it closes about itself, it curls up like burning paper, becoming stronger, more self-contained and more

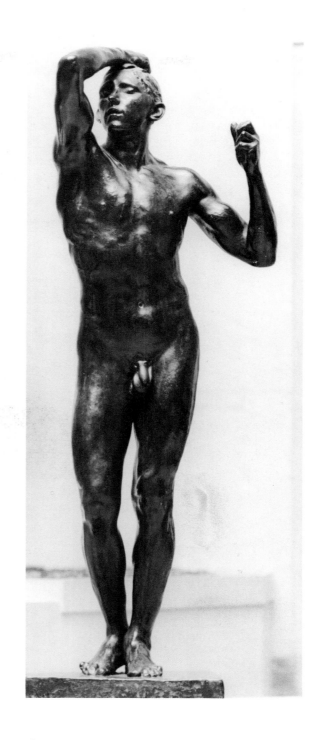

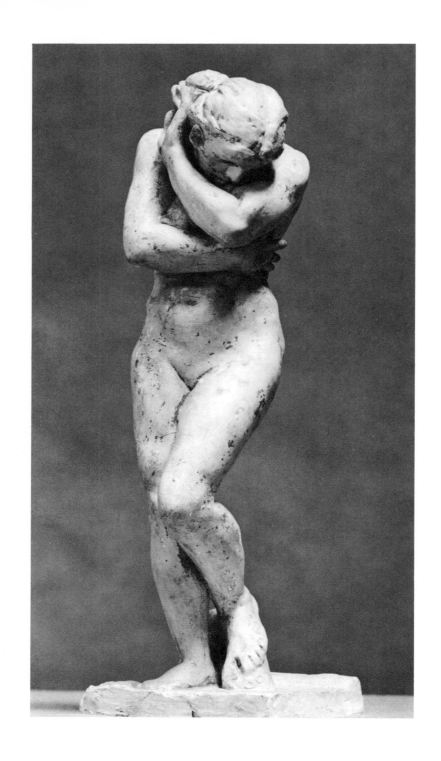

animated. Such is the figure of Eve, which was originally intended to stand above The Gates of Hell. Her head sinks down into the darkness of her arms, which clasp her breast like someone freezing. Her back is rounded, her neck almost horizontal; her posture is bent forward as if she were listening to her own body, in which an alien future begins to stir. And it is as though the gravity of this future works upon the senses of the woman, drawing them downward, out of her distracted life, into the deep and humble servitude of motherhood.

Again and again Rodin returns in his figures to this inward bending, to this concentrated listening to one's own depths, as in that wonderful form that he called Meditation, or the unforgettable Interior Voice, that softest song of Victor Hugo, which is almost concealed beneath the Voice of Anger on the monument to the poet. Never has a human body been so concentrated about its inwardness, so bowed by its own soul and yet restrained by the elastic strength of its blood. The way in which the neck lifts up a little from the body bending deeply sideways, and stretching, holds the listening head above the distant rush of life, is so moving and grandly conceived that one cannot recall a more striking and intimate gesture.

One notices that the arms are missing. Rodin felt in this case that arms would provide too easy a solution to his problem; that they were something that did not belong to the body, which wanted to be veiled within itself without outside help. One recalls the Duse; how, in one of d'Annunzio's dramas, when painfully abandoned she attempted to embrace without her arms and to clasp without hands. This scene, in which her body learned a caress that passed far beyond it, belongs to the unforgettable moments of her acting. She conveyed the impression that arms were an excess, an adornment, something for the rich and the profligate, which one could cast aside in order to be truly poor. In that moment she didn't seem to have given up anything important; she was more like someone who had given away her goblet in order to drink from a brook, like a person who is naked and still a little helpless in the depths of his exposure. It is the same with the armless statues of Rodin: nothing necessary is missing. One stands before them as before something whole, perfected, which allows no augmentation. Not from simple seeing does the feeling of incompleteness derive, but rather from circumstantial considerations, from the trivial pendantry that says that arms belong to a body, and in no case can a body be complete without arms.

It has not been very long since men rejected the trees of the Impressionists that are cut off by the picture frame for the same reason. We have become familiar with this effect rather rapidly; we have learned to perceive and to believe, at least regarding paintings, that an esthetic whole does not necessarily correspond to the wholeness of an object, that new unities arise independently within the picture, new alliances, relationships and balances. It is not different in sculpture. It is given to the artist to form one thing out of many or to shape a world from the smallest part of one thing.

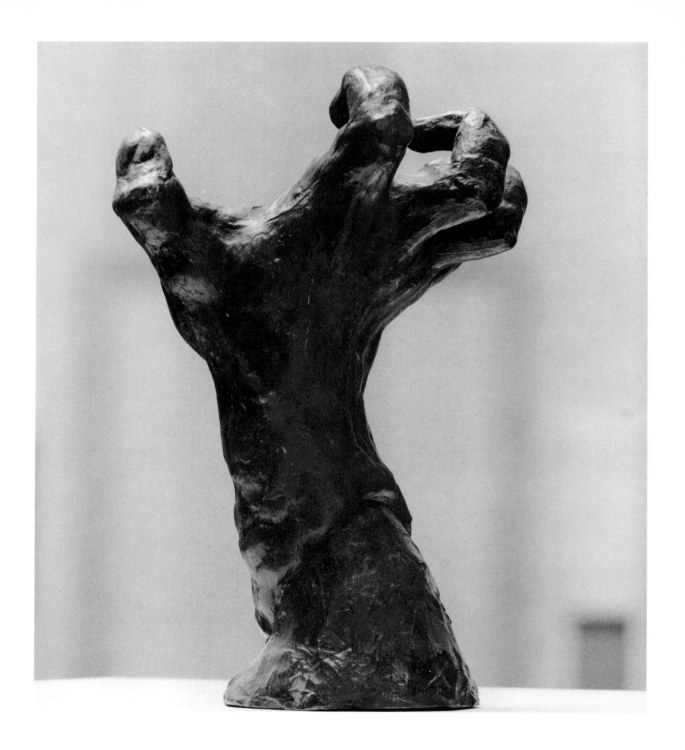

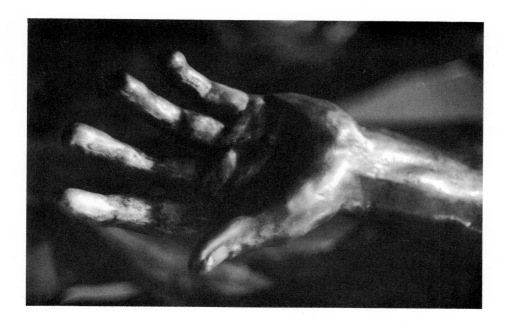

There are hands in Rodin's work: small, independent hands which live without belonging to any body. Hands which leap up, irritated and spiteful; hands whose five bristling fingers seem to bellow like the five throats of a hell-hound. Hands that walk, sleeping hands, and hands that awaken. Criminal hands, cursed with heredity, and those that are tired, that no longer want anything, that have laid themselves down in a corner like sick animals who know that no one can help them. But hands are already a rather complicated organism, a delta into which much life has flowed from distant origins to bathe in the great stream of action. There is a history of hands; they have, indeed, their own culture and their particular beauty, and one must concede to them the right to their own evolution, their own wishes, feelings, moods and romances.

But Rodin, who, because of the training he has given himself, knows that the body consists wholly of showplaces of life, and that life can become individual and great in any of the body's places, has the power to give the independence and fullness of a whole to any part of this vast oscillating surface. Just as the body remains a whole for Rodin only so long as a common (inner or outer) action holds all its limbs and powers in sway, so may parts of different bodies, cleaving to one another out of inner necessity, be integrated by him into a single organism. A hand which rests on another's shoulder or thigh no longer belongs completely to the body from which it came. Something new comes to be out of it and the object that it touches or clasps, one thing more, which has no name and belongs to no one; and this new thing, with its own definite borders, becomes the object of the artist's concern.

This recognition is the foundation of Rodin's grouping of forms; from it arises this unexampled binding-together of figures, this cohesion of images, this never-letting-go at any price. He does not begin with figures that embrace one another; he has no models that he arranges and places together. He starts with the regions of most intense contact, as if at the high-points of the work. There, where something new comes into being, he sets in, dedicating all the mastery of his craft to the mysterious phenomena accompanying the appearance of a new thing. It is as though he works by lightning flashes which emanate from this one point, and sees only those parts of the entire body which are thus illuminated. The magic of that wonderful grouping of a girl and a man which is called The Kiss *lies in such a wise and just distribution of its life. One feels that waves are passing into these bodies from their touching surfaces, shudderings of beauty, intimation and power. This is why one seems to see the rapture of the kiss in every part of these bodies: it is like a sun that rises, and its light shines everywhere.*

But even more wonderful is that other kiss, about which, like a wall about a garden, the work called The Eternal Idol *rises. One of the replicas of this marble is in the possession of Eugène Carrière, and this clear stone lives in the still twilight of his house like a spring where there is always the same movement, the same ascent and fall of an enchanted force. A girl kneels. Her lovely body is bent gently backwards. Her right arm is extended behind her, where her hand has sought and found her foot. In these three lines, from which no path leads out into the world, her life has enclosed itself with all its mystery. The stone beneath her lifts her up while she is kneeling. And suddenly one seems to recognize in this attitude, into which this young girl has fallen out of weariness or reverie or loneliness, an ancient holy gesture in which the goddesses of distant and terrible cults were absorbed. This woman's head is bowed a little forward; with an expression of compassion, sublimity and patience she gazes, as from the reaches of a still night, down to the man, who sinks his face into her breast as into many blossoms. He also kneels, but lower, deeper in the stone. His hands lie behind him like worthless and empty things. The right hand is open; one looks into it. A mysterious greatness emanates from this group. As so often with Rodin, one doesn't dare assign a meaning to it. It has thousands. Thoughts pass over it like shadows, and behind each one it rises up again, new and enigmatic, in its clarity and namelessness.*

Something of the atmosphere of a Purgatorio *lives in this work. A heaven is near, but is not yet attained; a hell is near, and not yet forgotten. Once again, all radiance streams outward from a touch—from the touching of both bodies and the woman's touching of herself.*

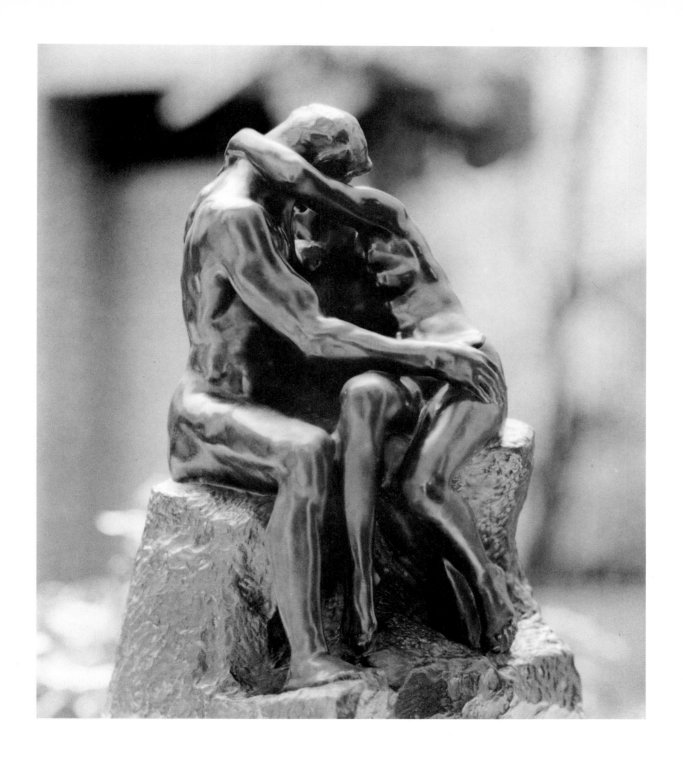

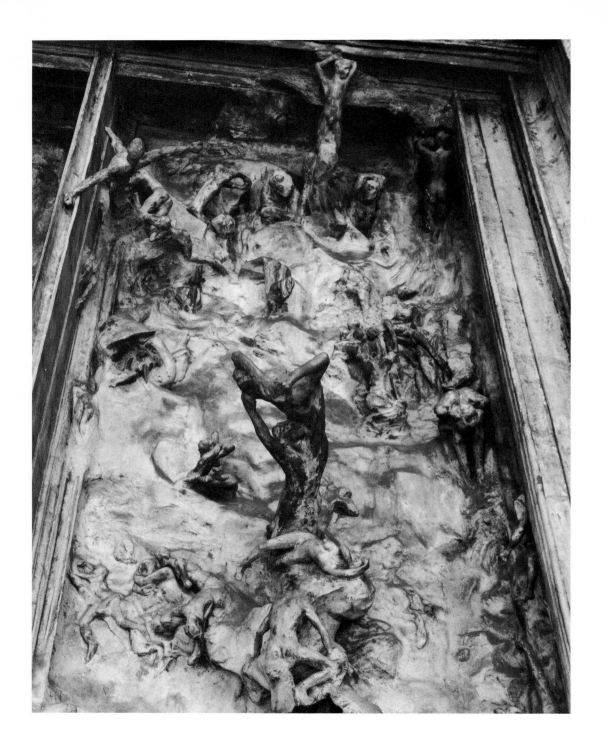

Even the mighty Gates of Hell, *on which Rodin has been working in solitude for the past twenty years, and which is almost ready to be cast, is merely an ever new elaboration of the theme of the contact of living and moving surfaces. Simultaneously developing his explorations of the movement of surfaces and of their unification, Rodin began to seek bodies which touched one another in multiple places, bodies whose mutual contact was more vigorous, stronger and more tumultuous. The more points of contact two bodies offered one another, the more impatiently they pressed toward one another, like chemical elements of great affinity, the more strongly and organically bonded was the new whole that they formed. Memories from Dante rose before him. Ugolino; and the wanderers themselves, Dante and Vergil, clasping one another; the throng of the voluptuous, from which, like a blasted tree, the groping gesture of avarice stretches. The centaurs, the giants and the monsters, sirens, fauns and wives of fauns, all the wild and ravenous god-beasts of the pre-Christian world appeared to him. And he created. He realized the forms and images of Dante's dream, lifted them upward, as from the turbulent depths of his own memories, and gave them, one after another, the soft redemption of embodiment. In this manner hundreds of groups and figures came to be. But the movements which he had found in the poet's words belonged to another time; they awakened in him who created, who had offered them resurrection, knowledge of a thousand other gestures: gestures of grasping and loss, suffering and release, which had evolved in the meantime; and his hands, which knew no weariness, pressed further and further beyond the world of the Florentine to ever new forms and gestures.*

This earnest, concentrated laborer, who never sought subject matter and wished no other fulfillment than what his ever maturing craft could achieve, came by this way into all of life's dramas. Now the depths of nights of love unfolded to him: dark expanses full of lust and grief, in which, as in a world still heroic, there were no garments, where faces were extinguished and only bodies mattered.

In search of life, his senses in white heat, he had approached the mighty tumult of this struggle, and what he saw was: life. Nothing about it was narrow, cramped or sultry. It was vast. The atmosphere of alcoves was remote. Here was life, a thousand times in every minute, in longing and lament, in madness and in dread, in loss and gain. Here was a desire that was immeasurable, a thirst so great that all the water in the world evaporated in it like a single drop. Here there were no lies and no denials; here the gestures of giving and taking were genuine and great. Here were vice and blasphemy, damnation and blessedness; and suddenly one understood that a world which concealed and buried all of this, which tried to act as if it didn't exist, must be very impoverished. It existed. Beside the history of man this other history had passed, and knew no disguises, no conventions, no differences or classes—only struggle. It also had its evolution. From a drive it had become a longing, from a lust between man and woman it had turned into a desire of one human being for another.

And thus it appears in Rodin's work. It is still the eternal battle of the sexes, but the woman is no longer the overpowered or docile animal. She is as awake and full of longing as the man, and it is as though they have come together in order that both may seek for her soul. The one who arises at night and goes softly to another is like a treasure-seeker who wishes to unbury that great happiness, which is so indispensable, at the crossroads of sex. In all vices, in all lusts contrary to nature, in all these despairing and lost attempts to discover an unending sense for existence, there is something of that longing which creates the great poets. Here mankind hungers beyond itself. Here hands stretch out toward eternity. Here eyes spring open and gaze on death and are not afraid; here a hopeless heroism is unfolded, whose fame comes like a smile and goes as a rose blooms and breaks. Here are storms of wishes and stillnesses of expectation; here are dreams that turn into acts, and acts which vanish into dreams. Here, as on some gigantic gaming-table, a fortune of power is won or lost.

All of this is found in Rodin's work. He, who had already passed through so much life, found here life's fullness and overflow. Bodies whose every part was a will. Mouths taking the form of a cry that seemed to rise from the depths of the earth. He discovered the gestures of primordial gods, the beauty and suppleness of animals, the delirium of ancient dances and the movements of forgotten worship, all strangely bound to the new gestures which had come about in the long interval when art was turned away, blind to all these revelations.

These new gestures were especially interesting to him. They were impatient. Just as someone who has looked a long time for an object becomes ever more perplexed, more distracted and hurried in his movements, creating disorder about himself, a pile of things which he has wrenched out of their places as if to compel them to help him look, so the gestures of mankind, which cannot discover their own meaning, have become more impatient, more nervous, more abrupt and hasty. And all the ransacked questions of existence lie in heaps about them.

But these movements have at the same time also become more hesitant. No longer do they possess that gymnastic and resolute directness with which earlier men came to grips with everything. They are not like those movements preserved in ancient works of sculpture, gestures for which only the starting point and the end point were important. Numberless transitions have been introduced between these two simple moments, and it is evident that the entire life of contemporary man, all his actions and his inability to act, has taken place within these intervening states. His grasp has changed, his beckoning, his letting-go and holding. In everything he is much more experienced, and yet at the same time more unknowing. He exhibits much less spirit and a perpetual concern with opposition, more despair at loss, more deprecation, judgment, deliberation, and less spontaneity.

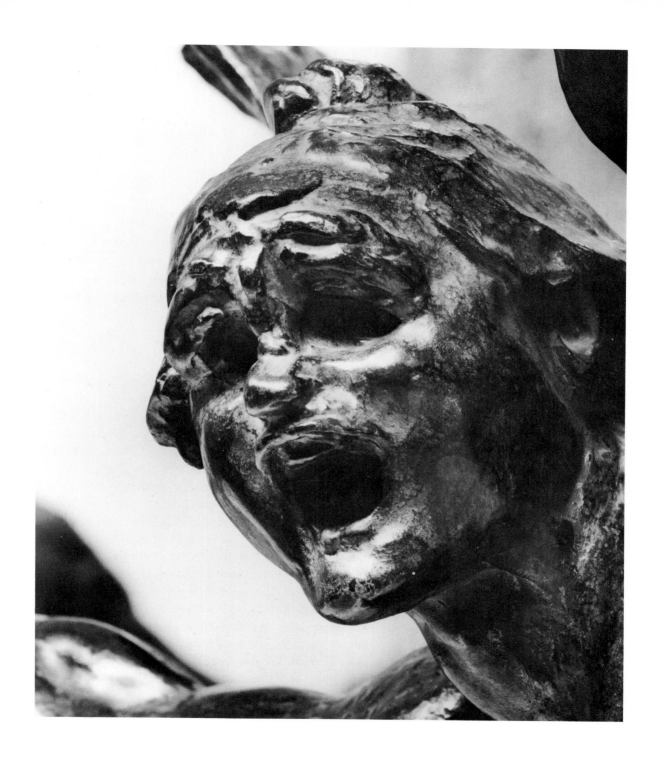

Rodin created these gestures. He made them out of one or many forms, shaped them into things after his fashion. He made hundreds and hundreds of figures, which were only a little larger than his hands, to bear the life of all passions, the blossom of all desires, the burden of all vices. He created bodies that touched each other everywhere, that grappled like beasts locked in one another's fangs, that plunged as a single thing into the depths; bodies that listened like faces and stretched outward like arms; chains of bodies, garlands and tendrils, and heavy clusters of forms, to which the sweetness of sin rose from the roots of suffering. Only Leonardo, in his grandiose depiction of the end of the world, had joined men together with equal power and authority. As in that work, here too there were those who cast themselves into the abyss in order to forget the great evil, and those who dashed out their children's brains so that they would not grow up to know it.

The horde of these figures grew far too numerous to fit within the wings and the pilasters of The Gates of Hell. *Rodin selected and selected. He eliminated everything that was too solitary to subordinate itself to this vast collectivity and everything that was not completely necessary to its coherence. He allowed the figures and the groups to find their own place; he observed the life of the people he had created, listened to them, and did the will of each. Thus did the world of the gate gradually evolve.*

Its surfaces, to which the sculpted forms were joined, began to come to life; in ever softer reliefs the vitality of the figures echoed into the background. On both pilasters the predominating movement is one of climbing, upward-striving, raising-high; on the wings there is falling, slipping and plummet. The wings recede slightly and their upper edge is separated from the protruding lip of the lintel by a rather large area. In front of this, in a still, enclosed space, sits the figure of The Thinker, *the man who perceives the full scope and terror of this drama because he is thinking it. He sits, absorbed and mute, gravid with images and thoughts, and all his power (which is the power of one who acts) is thinking. His entire body has become a skull, and all the blood in his arteries, a brain. He is the centerpoint of the gate, although above him on the lintel's crest three men are standing. The depths affect and shape them from a distance. They have inclined their heads together, and their three arms are extended forward, meeting to point toward the same place, into the same abyss, which draws them downward with its gravity. But* The Thinker *must bear it within himself.*

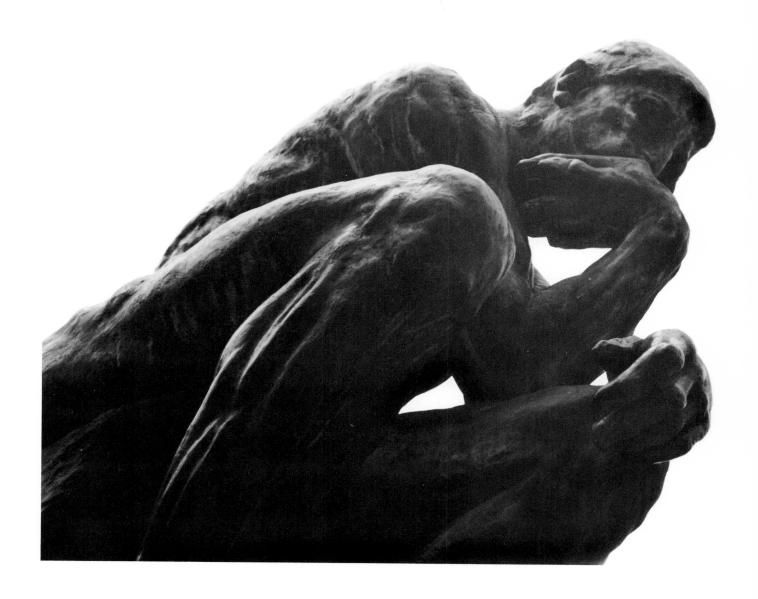

Among the groups and figures occasioned by this gate, there are many of surpassing beauty. It is as impossible to enumerate them all as it is to describe them. Rodin himself once said that he would have to speak for a full year in order to replicate one of his works with words. One can only say that these small figures, worked in plaster, bronze or stone, like many of the small animal figures of antiquity, give the impression of being very large. In Rodin's studio there is a cast of a panther of Greek workmanship hardly as large as a hand. (The original is found in the medallion cast at the Bibliotheque Nationale *in Paris.) When one looks under its body into the space formed by its four lithe and mighty paws, it can seem that one is gazing into the depths of an Indian rock temple, so expansively does it grow to the magnitude of its proportions. The small sculptures of Rodin are like this. By giving them many places, innumerably many perfect and definite surfaces, he makes them large. The air surrounds them as it surrounds rocks. If they rise, it seems as if they were heaving heaven upwards, and their fall sweeps the stars in its wake.*

During this time perhaps The Danaid *was also created; she who has cast herself down from her knees into her flowing hair. It is wonderful to pass about this marble slowly: the long, long way about the rich, unfolding curve of the back, to the face which loses itself in the stone as in a great weeping, to the hand which, like a final blossom, speaks gently one last time of life, deep within the eternal ice of the block. And* Illusion, the Daughter of Icarus, *this dazzling embodiment of a long helpless fall. And the lovely group which is called* The Man and his Thought, *the representation of a man who kneels and, with the touch of his brow, wakes from the stone before him the gentle outline of a woman, which remains bound to the stone. If one dares to interpret this, one may well rejoice over this expression of the inseparability with which the thought is joined to the man's forehead: for it is always only his thought that lives and lies before him; directly behind it is stone.*

Akin to this is the head which, still and reflective, has freed itself down to its chin from a great stone: Thought, *this piece of clarity, being and vision, lifting itself slowly from the ponderous sleep of inanimate duration.*

And then the Caryatid. *No longer an upright figure who bears, with ease or difficulty, the burden of a stone which she has really only positioned herself under, since it was already in place; but rather a female figure, kneeling, bent over, thrust down and wholly formed by the hand of the load whose weight sinks like a perpetual fall into all of her limbs. The whole stone weighs upon each small part of this body like a will that is greater, older and mightier than it; and yet the fate of bearing it has not come to an end. It bears, as in a dream one bears the impossible and finds no deliverance. Even its collapse and failure has remained a way of bearing. And when further weariness arrives and forces this body down so completely that it is lying, then this lying shall also be a form of bearing, bearing without end. Such is the* Caryatid.

If one desires, one can accompany, illuminate and circumscribe most of Rodin's works with ideas. For anyone for whom simple seeing is too unfamiliar and difficult a path to beauty, there are other paths, detours across meanings, which are noble, great and full of significance. It is as if the unending goodness and truth of these figures, the perfect equilibrium of their movements, the wonderful inner justice of their relationships, their saturation with life—as if everything that makes them beautiful things also lends them the power to be unsurpassable realizations of the subject matter that the master called forth when he named them. For Rodin the subject matter is never bound to the thing of art like an animal to a tree. It dwells somewhere in the environment of the thing and lives by means of it, somewhat like the custodian of a museum collection. One can learn much by calling him; but if one knows enough to get by without him, then one learns yet more, undisturbed in one's solitude.

Where the first impulse proceeds from the subject matter, where an ancient legend, a passage from a poem, an historical scene or a real person is the occasion for his creation, once Rodin begins, such subject matter is transformed ever further through the process of his labor to the concrete and the nameless. Translated into the language of hands, the resulting requirements all take on a new sense, conditioned wholly by the fulfillment of the sculpture.

In his sketches Rodin prepares for this process of forgetting and transforming the material impulse. In this art too he has developed his own style of expression, which makes these pages (of which there are several hundred) an independent and original revelation of his personality.

The first of these, from earlier days, are ink drawings with surprisingly strong chiaroscuro effects, such as the famous Man with the Bull, *by which Rembrant comes to mind, or the head of the young St. John the Baptist, or the shrieking mask of the Genius of War: primarily notes and studies to help the artist perceive the life of the surfaces and their relationship to the atmosphere. Then come figures sketched with head- long confidence, forms filled out in all their contours, fashioned by many rapid pen- strokes; and others, enclosed in the melody of a single vibrating outline, from which a gesture rises with unforgettable purity. Such are the sketches with which Rodin illustrated a copy of* Les Fleurs du Mal *at the request of a collector of sensibility. To speak of a very deep understanding of Baudelaire's verse says nothing; it is more to remember how these poems allow, in their self-saturation, no supplementation and no transcendence, and yet that one senses both completion and enhancement where Rodin's lines cling to this work: one measure of the enthralling beauty of these pages. The pen sketch drawn beside the poem "La mort des pauvres" reaches out from these great verses with a gesture of such simple, constantly evolving greatness that it seems to fill the world from its rising to its setting.*

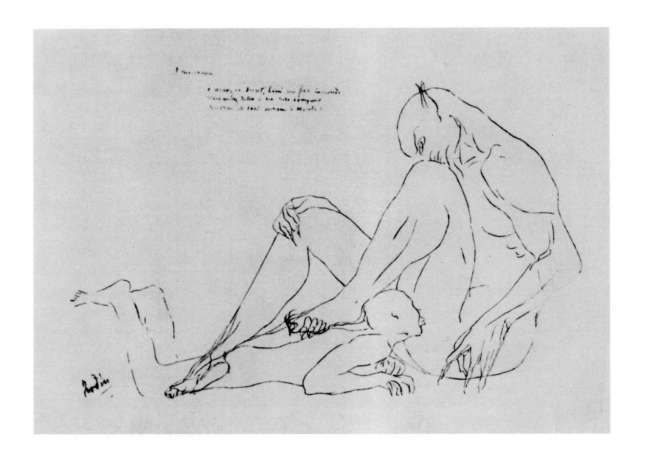

Such also are the drypoint etchings, in which the flow of endlessly gentle lines appears like the outermost contour of a lovely glass thing, which, exactly defined in every moment, encloses the essence of a reality.

But finally come those unique documents of the momentary, of the passage of the imperceptible. Rodin surmised that inconspicuous movements made by the model when he felt himself unobserved, if rapidly transcribed, should contain a strength of expression that we cannot imagine, because we are not accustomed to meet them with an intense and active attention. By never letting the model out of his sight and entrusting the paper entirely to his experienced and rapid hand, he was able to sketch a great number of gestures never before seen or noticed. And it was true that the power of expression that came from them was immense. Correlations of movements that had never been observed or recognized as wholes were depicted there, and they contained all

the immediacy, weight and warmth of pure animal life. A brush full of ochre, drawn with shifting accentuation rapidly through a contour, modeled forth the enclosed surface with such incredible intensity that one seems to behold a figure sculpted from burnt earth. Again, a whole new expanse had been discovered, full of nameless life; a depth, above which countless steps had echoed, gave its water to the one in whose hands the willow wand had spoken.

With portraits as well, the rendering of the subject in sketches belonged to the preparations by which Rodin passed, slowly and with concentration, toward the distant work. For however incorrect it is to see his art as a kind of Impressionism, nevertheless it has always been the vast resources of his precise and boldly grasped impressions from which he finally selects what is most important and essential to be integrated into a perfected synthesis.

When he passes from bodies that he has explored and shaped to faces, it must sometimes seem to him as though he had stepped out of a windy, tempestuous street into a narrow room where many people are present. Here everything is crowded and dark, and the mood of an interior reigns under the arches of the brows and in the shadows of the mouth. While there is always alternation and the thrust of waves across a body, ebbtide and flood, in a face there is air. It is like a chamber in which many things have taken place, joyous and fearful things, difficult and full of expectation. And no occurrence has completely passed away, none has taken the place of another; each has been set beside the other and has stayed there, withering like a flower in a glass. But whoever comes from out of doors, out of the great wind, brings distance with him into the room.

The mask of The Man with the Broken Nose *was the first portrait that Rodin created. In this work the manner in which he renders a face is already wholly mature; one senses his unlimited devotion to what is at hand, his respect for every line that fate has drawn, his trust in life, which creates even when it disfigures. In a sort of blind faith he had created* The Man with the Broken Nose *without inquiring who the man was whose life was passing once more through his hands. He had made him as God made the first man, without intending to achieve anything but life, nameless life. But he returned to men's faces ever more experienced, ever more knowing, ever greater. He could no longer observe their features without thinking of the days that had labored on them, this army of handworkers, occupied incessantly with a face, as though it would never be finished. From a still and conscientious reiteration of life had come, in his maturity, a first groping and hesitant but then ever more sure and bold interpretation of that script with which faces are entirely covered over. He gave no play to his imagination; he did not invent. Not for a moment did he disdain the ponderous progress of his craft. It would have been so very easy to outdistance it with any kind of wings. But he walked beside it as before, walked the whole long stretch that must be walked, walked like the plowman behind his plow. But as he was digging his furrow, he contemplated his land and the depth of his land; he contemplated the sky above him and the course of the wind and the fall of the rain; he contemplated everything that was and suffered and passed away and came again and never ceased to be. And in all of that, less confused by multiplicity, he seemed better now to recognize the eternal—for whose sake even suffering was good, and difficulty became motherhood, and pain was beautiful.*

This interpretation, which began with the portraits, grew from then on ever further into his work. It is the final step, the outermost sphere of his vast development. It started slowly. With infinite caution Rodin entered upon this new way. Once again he passed from surface to surface, following nature and listening to her. It was as if she herself pointed out those areas in which he knew more than there was to see. And when he focused on these, and created a great simplicity out of many little confusions, he did as Christ had done, when with sublime parables he had cleansed men full of unclear questions of their guilt. He fulfilled an intention of nature. He perfected something that had been helpless in its own development, unveiling correspondences as the evening of a foggy day unveils the mountains, which then undulate in ponderous waves into the distance.

Filled with the living burden of all his knowledge, he gazed into the faces of those who lived about him like a man from the future. This gives his portraits not only their uncommonly clear definition, but also that prophetic grandeur, which in the images of Victor Hugo or of Balzac was elevated to indescribable perfection. To create a likeness was for him to seek eternity in a given face, that portion of eternity through which it takes part in the vast course of eternal things. There was nothing he had formed that he

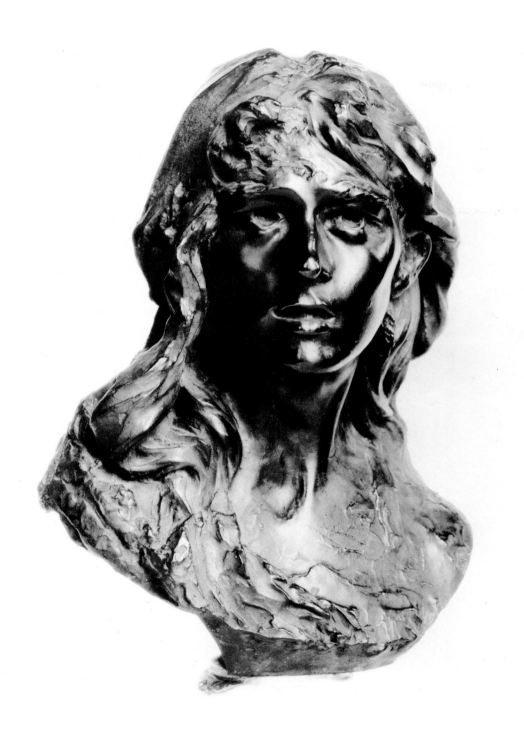

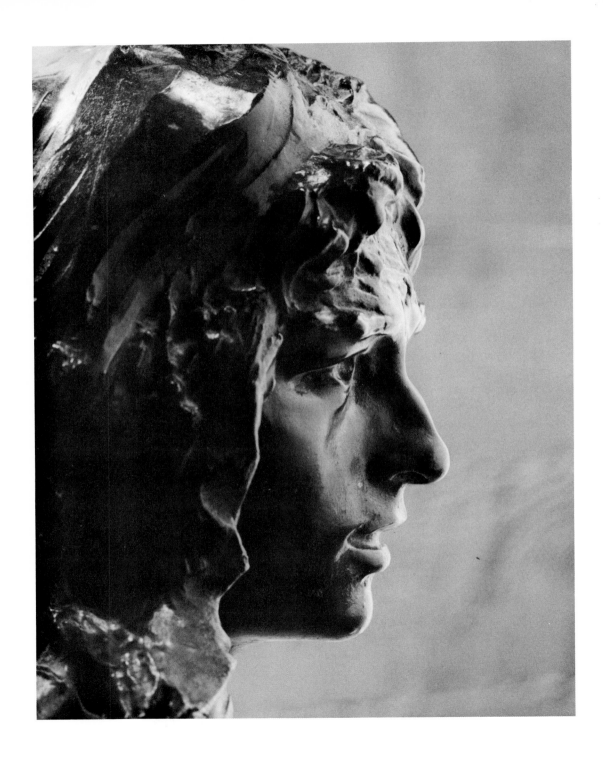

hadn't shifted the slightest bit into the future, as one holds a thing before the sky to observe its outline more clearly and simply. This is not what is called beautifying; nor is making characteristic an appropriate term for it. It is more than this; it is to separate the lasting from the transitory, to hold judgment, to be just.

Even excluding the etchings, his portrait work embraces a large number of completed and masterful likenesses. There are busts in plaster, in bronze, in marble and sandstone, heads in fired clay and masks simply dried in the air. Likenesses of women turn up repeatedly in all periods of his work. The famous bust in the Luxembourg Museum is one of the earliest. It is full of individual life, lovely with a certain feminine magic; but it is surpassed in simplicity and coherence of surface by many later works. It is probably the only one of Rodin's figures whose beauty does not come primarily from the virtues peculiar to the sculptor. In part it lives as well by virtue of that grace which has been the heritage of French sculpture for centuries. It glistens just a little with that elegance which even the poorer sculpture of the French tradition still exhibits; it is not wholly free from the gallant conception of the belle femme, *beyond which the earnest, deeply committed labor of Rodin so quickly matured. But it is well to remember in this regard that he also had to overcome this ancestral feeling, that he had to suppress an inherited ability in order to begin in total poverty. And this doesn't mean that he had to cease being French: the masters of the cathedrals were French too.*

The later likenesses of women have another, more deeply grounded, less facile beauty. It is perhaps worth mentioning here that it was mostly foreigners, American women, whose portraits Rodin executed. Among these are many of wonderful workmanship. Stones, like antique cameos, pure and untouchable. Faces whose smiles are nowhere fixed and play so lightly over their features that they seem to flutter like a veil with every breath. Lips closed enigmatically and eyes that gaze past everything in an eternal moonlit night, opened wide into a dream. And yet it is as though Rodin liked best to sense the female face as part of a beautiful body, as though he wished its eyes to be the eyes of the body, its mouth to be the body's mouth. Where he thus perceived and created as a whole, the face gained such an intense and enthralling expression of unrevealed life that it far surpasses his female portraits, even though they are apparently more precisely detailed.

It is different with the likenesses of men. It is easier to imagine the essence of a man concentrated within the breadth of his face. One can even conceive of moments (as in rest or inner agitation) in which all his life has entered his face. When he wishes to render the portrait of a man, Rodin chooses such moments. Or better: he creates them. He draws far back. He gives little weight to the first impression, or to the second, or to any of the rest. He observes and notes. He notes movements that are not worth a word, turnings and half-turnings, forty foreshortenings and eighty profiles. He catches his model in his habits and his accidental postures, in expressions that are just emerging,

in weariness and in exertion. He recognizes all the transitions in his features, knows from whence his smile comes and where it shall slip back to. He experiences the face of a man as a scene in which he himself takes part; he stands in its midst and nothing that occurs is indifferent to him, nothing escapes him. He does not allow himself to be told anything about the subject; he knows only what he sees. But he sees everything.

In this way much time is spent on every bust. The material grows, partly in sketches composed of a few pen-strokes and patches of ink, partly collected in memory, for Rodin has trained this faculty to be a ready and reliable means of assistance. He perceives far more during the hour of sitting than he can execute in such a short time. But he forgets none of it, and often after the model has left, the actual work begins for him out of the abundance of his memory. His memory is vast and spacious; impressions are not altered in it, but grow familiar with their dwelling; and when they rise from it into his hands, it is as if they were the natural gestures of those hands.

This manner of working leads to powerful compositions of hundreds and hundreds of moments of life; and this is exactly the impression made by the busts. The many remote contrasts and the unexpected transitions which shape a man in his perpetual development meet one another here in many happy encounters and hold each other fast with an inner power of adhesion. These men are integrated across all the reaches of their being; all climates of their temperaments unfold across the hemispheres of their heads. There is the sculptor Dalou, *in whom a nervous weariness vibrates beside an enduring, avaricious energy. There is the adventurous mask of* Henri Rochefort. *There is* Octave Mirbeau, *in whom the dream and longing of a poet glimmers behind the man of action; and* Puvis de Chavannes, *and* Victor Hugo, *whom Rodin knows so precisely.*

And above all, there is that indescribably beautiful bronze, the likeness of the painter Jean-Paul Laurens. *This bust is possibly the most beautiful piece in the Luxembourg Museum. It exhibits such a deep and at the same time grandly conceived development of its surfaces, it is so integrated in its pose, so intense in expression, so animated and alert, that one is never free of the feeling that nature herself has taken this work from the sculptor's hands, to embrace it as one of her favorites. The splendid patina, whose smoke-black tarnish breaks out like fire across the metal, spewing and flaming, contributes much to the perfection of this work's uncanny beauty.*

There is also a bust of Bastien-Lepage, *beautiful and melancholy, with the expression of the sufferer, whose labor is a continuous farewell to his work. It was made for Damvillers, the small home village of the painter, and is placed there in the churchyard. Thus it is actually a monument. And all the busts of Rodin, in their completeness and their concentration passing into magnitude, have something monumental about them. With this one it is only a matter of a further simplification of its surfaces and an even more stringent selection of what is required for its being visible from a distance. The monuments made by Rodin approached these requirements ever more closely. He*

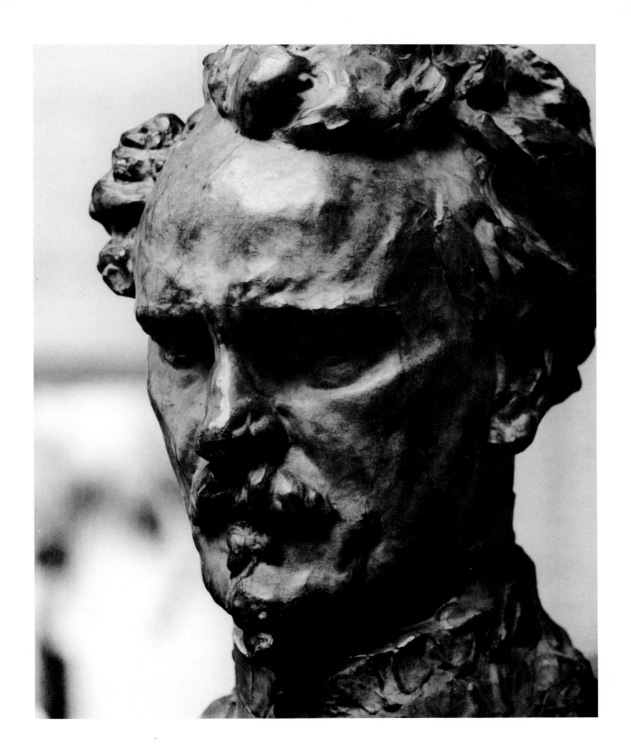

began with the memorial to Claude Gelée for Nancy; and it is a steep ascent from this first interesting attempt to the grandiose success of Balzac.

Many of Rodin's monuments have been shipped to America, and the most mature of these was destroyed in the disturbances in Chile before it could even be brought to its resting place. This was the equestrian statue of General Lynch. Like Leonardo's lost masterwork, which it perhaps resembled in its power of expression and its wonderfully inspired unity of man and steed, it was not to survive. But judging from a small plaster model in the Musée Rodin at Meudon, it was an image of a lean man, sitting upright in the saddle, who gives commands not in the brutal, lordly manner of a Condottiere, but more nervously, with greater agitation, more as one who exercises his power merely as a duty, rather than making it his life.

Already in this work the forward-pointing hand of the general is lifted entirely out of the mass of the statue, apart from man and beast. And it is also this circumstance which gives the gesture of Victor Hugo its unforgettable majesty, its far-flung procreance, this power that one believes in at first sight. The old man's great and living hand, which is speaking with the sea, has not come from the poet alone; it has descended from the summit of the whole group, as from a mountain where it prayed before it spoke. Here Victor Hugo is the exile, the man of solitude from Guernsey; and it is one of the wonders of this monument that the muses which surround him do not look like apparitions haunting somebody forsaken; on the contrary, they are his solitude grown visible. Through the emotional intensity of the figures and their concentration about what one might call the interior of the poet, Rodin achieved this impression; by proceeding again from an individualisation of the points of contact, he succeeded in making these wonderfully animated figures virtually the organs of the sitting man. They surround him like gestures he had once made, gestures that were so young and lovely that a goddess gave to them the grace never to pass away, but to endure forever in the form of beautiful women.

Rodin made many studies for the figure of the poet. During the receptions at the Hotel Lusignan, from a window alcove he observed and noted hundreds and hundreds of the old man's movements and all of the expressions of his animated face. Out of these preliminary sketches came the portraits of Hugo that Rodin made. But for the monument a still deeper penetration was necessary. He thrust all of his individual impressions aside, and comprehended them again from a distance; and as men perhaps had once fashioned one figure out of a whole line of rhapsodists and called him Homer, so he created one image out of all the figures in his memory. And upon this one last image he bestowed the grandeur of the legendary; as though in the end it could have only been a myth, which went back to some fantastic rock jutting out of the sea, in whose strange shapes remote tribes saw a gesture sleeping.

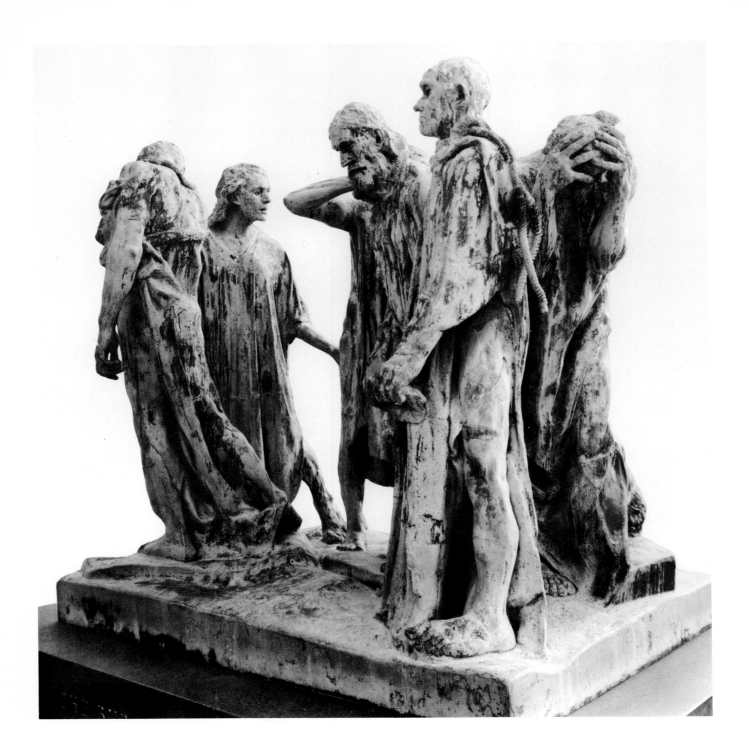

This power of raising the past to deathlessness was manifest by Rodin each time he needed to bring historical figures or material to life within his art, but perhaps most superbly in The Burghers of Calais. *The available subject matter was limited to a few columns in Froissart's* Chronicle. *It was the story of the seige of the town of Calais by the English king, Edward III: how the king refuses mercy to the town now desperate with the fear of starvation; how the same king finally agrees to raise the seige if six of the town's noblest burghers deliver themselves into his hands, "that he might do with them according to his will." He demanded that they should leave the town bareheaded, clad only in their shirts, nooses about their necks and the keys to the town and its citadel in their hands. The chronicler now describes the scene within the town; he reports how the mayor, Messire Jean de Vienne, commanded that the bells be rung, and how the burghers gathered in the marketplace. They have heard the fearful tidings and now wait in silence. But already the heroes among them are rising—the chosen, who feel within themselves the calling to die. At this point the cries and wailing of the multitude crowd through the chronicler's words. For a while he himself seems quite overcome, and to write with a trembling pen. But he composes himself again. He names four of the heroes; he has forgotten the names of the other two. He says of one that he was the richest burgher in the town; of another, that he possessed position and wealth and "had two lovely maidens for daughters." Of the third he knows only that he was endowed with fortune and inheritance, and of the fourth that he was the brother of the third. He reports that they stripped down to their shirts, that they bound the nooses about their necks, and that they then set out in this wise, bearing the keys to town and citadel. He tells how they entered the king's camp; he describes how harshly the king received them and how the hangman was already beside them when the monarch, at the request of his queen, granted them their lives. "He heeded the pleas of his wife," says Froissart, "because she was with child." More the chronicle does not relate.*

But that was sufficient material for Rodin. He felt immediately that there was a moment in this story in which something great occurred, something that did not know of time or name, something unconditioned and simple. He turned his full attention to the moment of their setting out. He saw how these men began their steps; he felt how for each of them his whole life passed once more within him; how each, laden with his past, stood there, ready to bear it with him out of the old town. Six men rose up before him, and none was like another, except that two were brothers, between whom perhaps a certain similarity existed. But each of them had come to his resolve in his own fashion, lived these final hours in his own way, celebrating in his soul and suffering in his body, which clung to life. And then he saw their figures no longer. In his memory gestures arose, gestures of renunciation, gestures of departure, gestures of sacrifice. Gestures upon gestures. He gathered them in. He shaped them all. They flowed to him

out of the fullness of his knowledge. It was as if one hundred heroes rose up in his memory and thronged toward martyrdom. And he accepted the entire hundred and out of them made six. He formed them naked, each by himself, in the full eloquence of their shivering bodies. Larger than life: in the natural size of their resolve.

He created the old man with the hanging arms that are slack in the joints; and he gave him that heavy, shuffling step, the worn-out gait of the aged, and an expression of tiredness that flows across his face into his beard.

He created the man who carries the key. There is sufficient life in him for many years, all suddenly compressed into the final hour. He hardly bears it. His lips are pressed together; his hands bite into the key. He has set fire to his strength, and it burns in him, in his defiance.

He created the man who holds his bowed head in both hands, as though to gather himself for one more moment of solitude.

He created the two brothers, of whom one is still looking backwards, while the other inclines his head with an expression of resolution and surrender, as if he were already offering it to the hangman.

And he created the vague gesture of that man who "passes through life." Gustave Geffroy has called him "Le Passant." He is already passing by, but he turns about again, not to the city, not to the grieving crowd, and not to them who go with him. He turns about to himself. His right arm lifts, bends, wavers; his hand opens in the air and lets something go, somewhat as one releases a bird. It is a farewell to all uncertainty, to a happiness not yet come, to a suffering that now shall wait in vain, to men who may dwell anywhere and who one sometime might have met, to all the possibilities of tomorrow and the day after tomorrow, and also to that death which one had thought remote and mild and still at the far end of a long, long life.

This figure, placed by itself in an old dark garden, could serve as a memorial for all the early dead.

And thus Rodin gave a life to each of these men in the final gesture of their life.

The individual figures give an effect of exaltation in their simple grandeur. One thinks of Donatello, or possibly more of Claus Sluter and his prophets in the Chartreuse of Dijon.

It seems at first as if Rodin had done nothing further in joining them into a composition. He gave them each the common costume, the shirt and the noose, and placed them beside one another in two rows: the three who are already in the act of stepping forward in the first; the others behind, turning to the right as if they were just joining in. The site for which the monument was intended was the marketplace of Calais, the place where once the long walk had begun. There the silent figures would have stood, raised only slightly by a narrow step above everyday commerce, as if the fearful departure were to come at any moment, in the midst of every hour.

60

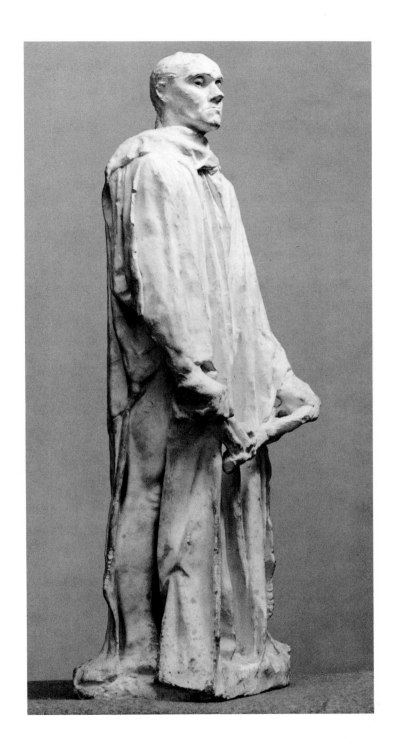

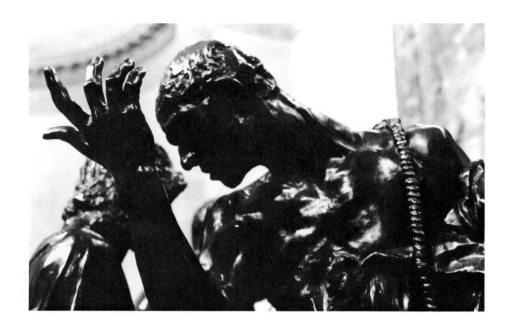

But in Calais they refused to accept such a low pedestal because it was contrary
to custom. So Rodin proposed another manner of placing it. He suggested that a tower
be erected hard against the sea, square, its girth equal to the statue's base, with plain
hewn walls two stories high; and there on top the six burghers would be set in the
solitude of wind and sky. As was easy to foresee, this proposal was also rejected. And yet
it was based upon the nature of this work. Had the proposal been accepted, we should
have had an unexampled opportunity to admire the integrity of the group, which consists
of six individual figures, and yet holds as firmly together as if it were a single thing.
And the individual figures do not even touch; they stand beside each other like the last
trees of a felled forest, and what unites them is only the air, which is involved with
them in a peculiar way. As one walks about this group one is surprised to see how the
gestures rise up, pure and great, out of the wave-thrust of the contours, lift themselves,
stand upright, and then fall back into the mass, like flags that have been furled. Every-
thing is clear and definite. Nowhere does there seem to be room for chance. Like all
the groups in Rodin's work, this one is self-contained, a world in itself, a whole, filled
with a life that circulates and never dissipates itself in outward currents. In the place of
contacts, here are overlappings, which are also a kind of contact, endlessly attenuated,
influenced and altered by the medium of the air that lies between. Contacts from a
distance have thus arisen, encounters, forms passing across one another, as can sometimes
be seen with cloud-masses or with mountains, where the air that is embedded between
is no abyss to separate them, but rather a conduit, a lightly graduated transition.

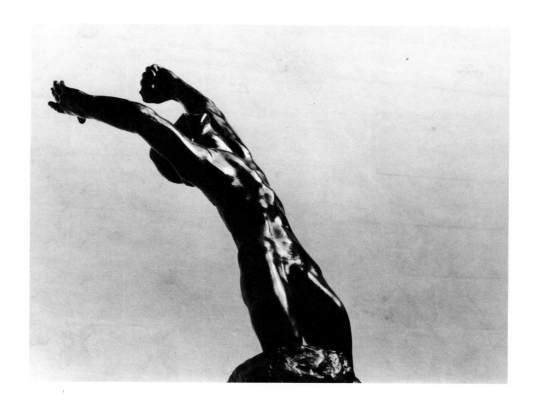

For Rodin the involvement of the air has always been of particular significance. Surface by surface he released all his things into space, and that gave them their magnitude and independence, this indescribable maturity which distinguishes them from all other things. But now, since he, in interpreting nature, had gradually approached the point of intensifying his expressions, it became evident that he was thereby also enhancing the relationship of the atmosphere to his work, that it surrounded the unified surfaces more animatedly or, as it seemed, more passionately. If earlier his things had stood in space, now it seemed as if space clasped them to itself. Something similar could be observed only in a few animals upon the cathedrals. The air was also involved with them in a peculiar way: it seemed to turn to stillness or to wind according to its passage over soft or accentuated places. And, in fact, when Rodin concentrates the surface of his work to highpoints, when he enhances elevations and gives greater depth to hollows, he deals with his work in the same way that the atmosphere has dealt with those things abandoned to it for centuries. It too has concentrated, deepened and removed dust, has reared these things with rain and frost, with sun and storm, to a life that passes ever more slowly in prominence, darkening, and duration.

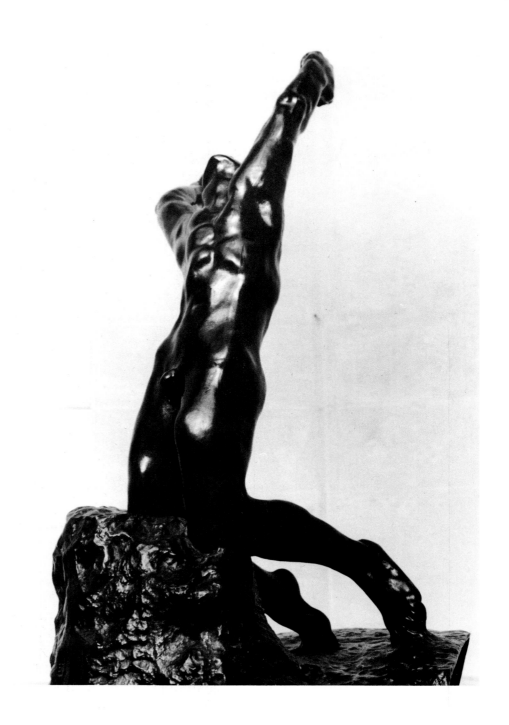

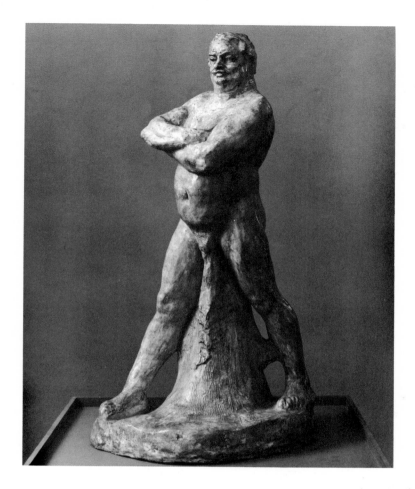

Already in The Burghers of Calais Rodin was well upon his way to this effect. In it lay the monumental principle of his art. With such means he could create things visible from a distance, things which were embraced not merely by the nearest surrounding air, but by the entire sky. He could trap distance in a living surface, as in a mirror, and bring it to life; he could shape a gesture which seemed great to him, and compel space to take part in it.

Such is the slender youth, who kneels and flings his arms upwards and backwards in a gesture of limitless appeal. Rodin called this figure The Prodigal Son, but all at once it had assumed the name Prayer as well, though no one seems to know how. And it has outgrown this name too. That is no son kneeling before his father. This gesture makes a God necessary. And all who need Him are contained in him who gestures. All distances belong to this stone; it is alone upon the world.

And such also is Balzac. Rodin gave it a grandeur which possibly overshadows the stature of the writer. He caught him in the very ground of his nature, but did not stop at his nature's limits. About its most remote and extreme possibilities, about what it had not attained, he drew this mighty contour, which seems prefigured in the gravestones of primordial peoples. Year after year he lived entirely in this figure. He visited Balzac's homeland, the landscapes of Touraine, which appear again and again in his books. He read his letters, he studied all the pictures of Balzac that existed, and he went repeatedly through his work. On all the branching and entangled pathways of this work he encountered the people of Balzac, whole families and generations, a world still appearing to believe in the existence of its creator, to see him and to live by his grace. He saw that all of these thousands of figures, whatever they might do, were completely occupied with the one who had made them. As one perhaps might guess what drama is playing on stage from the various expressions found on the faces of its spectators, thus he searched in all these faces for the one who for them had not yet departed. Like Balzac, he believed in the existence of this world, and for a while he succeeded in adapting himself to it. He lived as if Balzac had created him also, unobtrusively mingled among the multitude of his creatures. In this way he came to his most fruitful experiences.

What was otherwise available seemed less eloquent by far. The daguerreotypes offered only general perspectives: nothing new. Everybody had known the face that they depicted since his schooldays. Only one, which had been the property of Stéphan Mallarmé and showed Balzac without a coat and wearing suspenders, was more characteristic. The sketches of his contemporaries were more helpful: the words of Theophile Gautier, the notes of the Goncourts and the lovely portrait of Balzac written by Lamartine. Besides these there were only the bust by David in the Comédie-Française and a small likeness by Louis Boulanger.

Wholly filled with Balzac's spirit, Rodin now began to establish his outer appearance with the help of these guides. He employed living models with similar body proportions, and formed seven fully executed figures in various positions. The men whom he employed were all fat and stocky with ponderous limbs and short arms, and after these preliminary studies he created a Balzac more or less in the conception made familiar by Nadar's daguerreotype. But he felt that nothing final had yet been accomplished. He returned to Lamartine's descriptions. There he read: "He had the face of an element" and "He possessed so much soul, that it bore his heavy body as if it were nothing." Rodin sensed that in these sentences lay the greater part of his task. He came closer to a solution when he attempted to clothe all seven figures with monk's frocks of the sort that Balzac used to wear while he was working. This resulted in a Balzac-in-a-cowl, much too intimate, and far too withdrawn into the stillness of his costume.

But Rodin's vision grew slowly from figure to figure. And finally he saw him. He saw a broad, wide-striding figure that had lost all of its heaviness in the fall of its cloak.

Hair bristled on its powerful neck, and a face inclined into the hair, gazing, intoxicated with gazing, seething with creation: the face of an element. This was Balzac in the fertility of his abundance, the founder of generations, the squanderer of destinies. This was the man whose eyes required nothing; for had the world been a void, his glance would have peopled it. This was the man who had desired to be made rich by legendary silver mines and happy by a foreign lady. This was Creation itself, which had employed the form of Balzac in order to appear. This was the presumption of Creation, its arrogance, its rapture and its drunkenness. The head, thrown back, lived high atop the summit of this figure like a bead of water dancing on a fountain's jet. All heaviness had become light, and rose and fell.

Thus, in a moment of immense concentration and tragic hyperbole, had Rodin seen his Balzac; and thus he executed it. The vision did not pass away; it was transformed.

This development of Rodin, which surrounded the great and monumental things of his art with vastness, also endowed the others with new beauty. It gave them their own ambience. Among the latest works there are small groups which owe their effect to their self-containment and to the wonderfully gentle treatment of the marble. These stones retain, even in the middle of the day, that mysterious shimmer which white things exhale at twilight. This doesn't come only from the vitality of their places of contact; it is evident that flat bands of stone have been left here and there between the figures and between their individual parts, like bridges in the background that unite one form with another. This is not an accident. These strips prevent the development of worthless perspectives that lead from the thing into empty space; they have the effect that the edges of forms, which otherwise appear sharp and ground-off before such gaps, retain their curvature. They gather light like shells, perpetually overflowing. If earlier Rodin strove to lure the air as close as possible to his things, here it seems as though he had dissolved the stone directly into it. The marble appears merely to be the firm and fructive kernel, whose outermost and gentlest contour is oscillating air. The light that approaches this stone has no will of its own. It doesn't pass beyond it to other things; it nestles against it, hesitates and lingers; and then dwells in it.

This closure of unessential perspectives was a kind of approach to bas-relief. And indeed, Rodin plans a great work in relief, in which all the effects that he has achieved with light in smaller things may be united into one composition. He thinks of erecting a high column, around which a wide relief-band would wind upwards. A carpeted stairway would rise beside it, closed to the outside by arcades. The figures on the walls would live in this passageway as in their own atmosphere; and there would arise a plastic art that knows the secret of chiaroscuro, a sculpture of the twilight, kindred to those figures which stood in the vestibules of the old cathedrals.

This would be his monument to labor. A history of working would unfold upon this gradually ascending relief. The long band would begin in a crypt with images of

those who grow old in mountain quarries, and it would pass on its long way through every occupation, from the noisy and turbulent to ever more delicate operations—from blast-furnaces to hearts, from steam-hammers to brains. At the entrance there shall loom two figures: Day and Night; and at the summit two winged genii shall stand: the blessings which descend out of bright elevations to this tower. For this monument to labor shall be a tower. Rodin does not attempt to represent labor with a grandiose form or gesture; it is not what is visible from a distance. It is carried out in workshops, in closets, in heads; it proceeds in darkness.

He knows this, for his labor is also like this; and he labors incessantly. His life passes like a single workday.

He has many studios; well-known ones, where visitors and letters find him, and others, out of the way, which nobody knows about. These are cells; bare, impoverished rooms full of dust and grayness. But their poverty is like that great gray poverty of God, in which the trees awaken during March. They contain something of the beginning of spring: a gentle promise and deep earnest.

Perhaps the Tower of Labor is already taking shape in one of these workrooms. Because its realization still lies in the future, we must now speak of its meaning, which seems to consist of its subject matter. But when this monument has some day been achieved, then we shall feel that also in this work Rodin had not intended anything beyond his art. The laboring body has manifested itself to him, as earlier the loving body had. It is a new revelation of life. But this creator lives so exclusively among his things, so wholly in the depths of his work, that he can receive revelation in no other manner than through the simple medium of his art. For him, in its final significance, new life means new surfaces, new gestures. Everything about him has grown simple. He can no longer go wrong.

Through his development Rodin has provided an example for all the arts in this age void of counsel.

Some day men shall recognize what made this great artist so great. He was a laborer, who longed for nothing but to enter, wholly and with all his powers, the narrow, difficult existence of his craft. Therein lay a kind of renunciation of life; but it was precisely with such patience that he won it back: for the world unfolded to his craft.

69

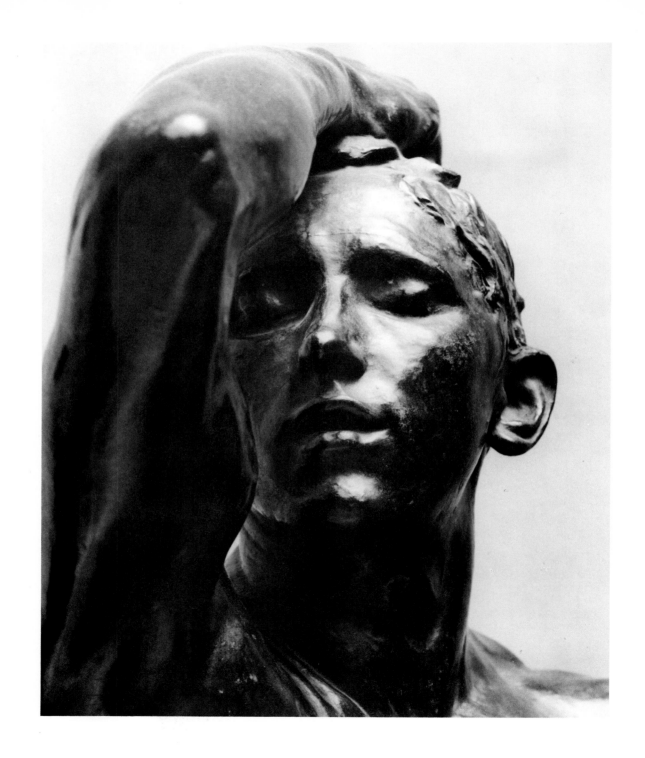

SECOND PART

There are a few great names which, if spoken at this moment, would generate a friendship between us, a warmth, a unity, which would make it seem that I—only apparently isolated—were speaking from your midst: proceeding from you as one of your voices. The name that shines brightly as a five-starred constellation above this evening cannot be spoken. Not yet. It would bring unrest upon you; currents of sympathy and of resistance would well up within you; while I must claim your silence and the untroubled surface of your good-willed expectation.

I ask those who are still able to forget the name in question, and I require of all an even vaster forgetting. You are all accustomed to addresses concerned with art, and who might conceal the fact that you are always more willingly predisposed toward words spoken on this subject? A certain intense and lovely movement, which may no longer be hidden, has caught your eye like the flight of a great bird; but now you are asked to lower your glance for the duration of an evening. For I shall not focus your attention there, in that heaven of uncertain developments. I will not make an augury for you from the bird-flight of the new art.

I feel like one who must remind you of your childhood. No; not merely of yours, but of everything that was ever childhood. For it is my purpose to awaken memories in you which are not yours, which are older than you, to restore relationships and to renew connections that lie far from you.

If it were of men I had to speak to you, then I could begin where you had just broken off when you entered this room; falling in with you conversations, I could meet everyone on his own level—borne and swept along by these turbulent times, on whose

shores everything human seems to lie, flooded by them, and mirrored in unexpected configurations. But when I attempt to survey my task, it becomes clear to me that it is not of men I have to speak, but of things.

Things.
As I pronounce it (do you hear?) a stillness rises: the stillness which surrounds a thing. All movement comes to rest, and turns to contour; out of past and future time something enduring closes: space, that great peace of things void of compulsion.

But no; as yet you do not feel the stillness rising here. The word "things" passes you by; it means nothing to you: too much, and something too indifferent. And thus I am glad that I have called forth childhood; perhaps it can help me to lay this word on your hearts, as something precious that is linked with many memories.

If you find it possible, return now with a portion of your weaned and grown-up feelings to any of your childhood things, one which you always had with you. Think whether there was ever anything closer, more intimate or more necessary to you than such a thing. Whether everything else was not in a position to harm you or to be unfair, to frighten you with pain or to bewilder you with uncertainty? If you found kindness in your first experiences, and trust and companionship—wasn't this because of it? Wasn't it a thing with which you first shared your little heart, like a piece of bread that must be large enough for two?

Later, in the legends of the saints, you discovered a devout joyfulness, a blessed humility, a readiness to be all things, which you already knew, because some little piece of wood had once done all of that for you, had taken it upon itself and borne it all. This small forgotten object, which was ready to mean whatever you wanted, made you familiar with thousands of things by playing thousands of roles. It was an animal or tree, a king or child—and when it withdrew, everything was there. This something, however worthless it might have been, prepared you for all your relationships to the world, it led you into events and among people; and what is more: in it, in its existence, in its appearing in any form, in its final breaking or mysterious disappearance, you experienced everything human, even to the depths of death.

But you barely remember that anymore, and are rarely aware that you still have need of things, which, like those things from your childhood, await your trust, your love and devotion. How do things bring this about? How may they be related to us at all? What is their history?

Already in earliest times men formed things, laboriously, after the example of those natural things they found about them. Men made tools and vessels, and it must have been a strange experience to see what one had made oneself so fully accepted, so equally legitimate, so real beside those things which were. Here, in wildest labor,

something blindly came to be, and bore upon itself the traces of a vulnerable and open life, and was still warm with it—but hardly was it finished and set down, when it took its place among the things, assumed their composure and their silent dignity, and merely gazed, as though entranced, with melancholy acquiescence out of its duration. This experience was so remarkable and so intense that it is easy to understand why all at once things were made for their own sake. The earliest images of gods were possibly applications of this experience, attempts of men to shape, out of the animal and human realms which they perceived, something that didn't die with them, something permanent, the next higher order: a thing.

What kind of thing? A thing of beauty? No. Who would have known what beauty is? A likeness. A thing in which men recognized what they loved and what they feared and what was beyond their understanding in everything.

Do you recall such things? Maybe there is something which had long only appeared ridiculous to you. But then one day you were struck by its insistence, by that peculiar, almost desperate earnestness that all things have; and did you not then notice how, almost against its own will, a beauty came over this image that you would not have believed possible?

If you have ever experienced such a moment, then I would now appeal to it. This is the moment in which things enter your life again. For a thing cannot touch you if you will not allow yourself to be surprised by a beauty that cannot be foreseen. Beauty is always something adventitious, and we don't know what.

The fact that there has been an aesthetic view which thinks that it might comprehend beauty has led you astray, and has called forth artists who see their task to be beauty's creation. And therefore it has never yet become superfluous to repeat that no one can "make" beauty. No one has ever made beauty. One may merely create friendly or lofty conditions for whatever sometimes may linger with us: an altar and fruit and a flame.

The other is not in our power. And the thing itself, which, irrepressible, comes forth from the hands of a man, is like the Eros of Socrates, is a daimon, *an intermediary between god and man, itself not beautiful, but purest love of beauty and purest longing for it.*

Now imagine how this insight, when it comes to a creator, must change everything. The artist who is guided by this perception does not have to think about beauty; he knows just as little as anyone else of what it consists. Guided by a compulsion toward the fulfillment of benefits beyond his grasp, he knows only that there are certain conditions under which beauty may perhaps consent to come to his things. And his calling is to learn these conditions and to achieve the ability to call them forth.

But to him who assiduously follows these conditions to their end, it is manifest that they never go beyond the surface and nowhere pass into the interior of a thing; that

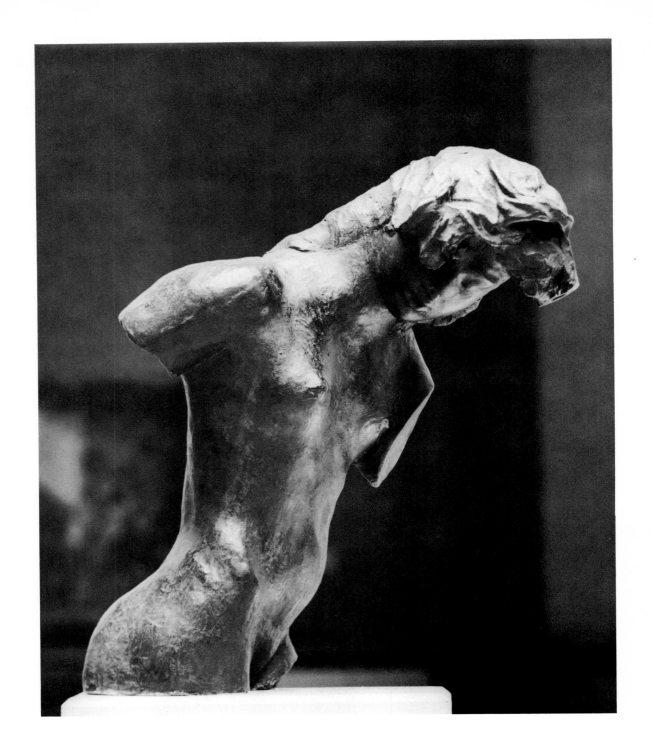

all a man can do is to produce a surface that is self-contained in a particular way, and in no place accidental; a surface which, like those of natural things, is surrounded by the atmosphere, shadowed and illuminated; only this surface—and nothing else. And all at once, from out of all those pretentious and capricious words, art seems to have turned into something lowly and sober, something everyday, into handwork. For what is it to make a surface?

But let us for a moment consider whether everything that is before us, which we perceive and interpret and explain, is not merely a surface. And what we call spirit and soul and love: isn't all of that just a gentle transformation of the modest surface of a near-by face? And he who wants to bring forth this image for us, must he not hold to what is palpable, to what is appropriate to his medium, to that form which he can grasp, with which he can sympathize? And whoever were able to perceive and to bring forth all forms, wouldn't he (almost without knowing it) be giving us everything spiritual? Everything that has ever been called longing or pain or blessedness, and even what can have no name in its unspeakable spirituality?

For all the happiness with which the heart has ever trembled, all greatness which nearly destroys us when we think of it, each of the vast world-transforming thoughts—there was a moment in which each of these was nothing but a pursing of lips, a raising of eyebrows, shadowed places on a forehead. And that line about the mouth, that crease above the eylids, that darkness on a face—perhaps they had already existed, just as they are, long before: as a marking on an animal, a furrow in a rock, an indentation on a fruit...

There is but one single, thousandfold moving and changing surface. In one moment someone could conceive the entire world with this thought; and it would be simple, and delivered as a task into the hands of him who thought it. For whether something can be turned into a life does not depend on great ideas, but rather on whether a hand-work can be created out of them—something daily, something persevering to the end.

I venture now to speak the name which can no longer be concealed: Rodin. You know it as the name of innumerable things. You ask about them, and it troubles me that I can't show you any of them.

And yet it seems to me as though I could see one and then another in your memory, as though I could withdraw them and set them here among us:

this Man with the Broken Nose, unforgettable as an abruptly upraised fist;

this Youth, whose upright, stretching movement is as familiar to you as your own awakening;

this Walking Man, which rises in the vocabulary of your feelings like a new word for going;

the one who sits, thinking with his entire body, drawing himself into himself;

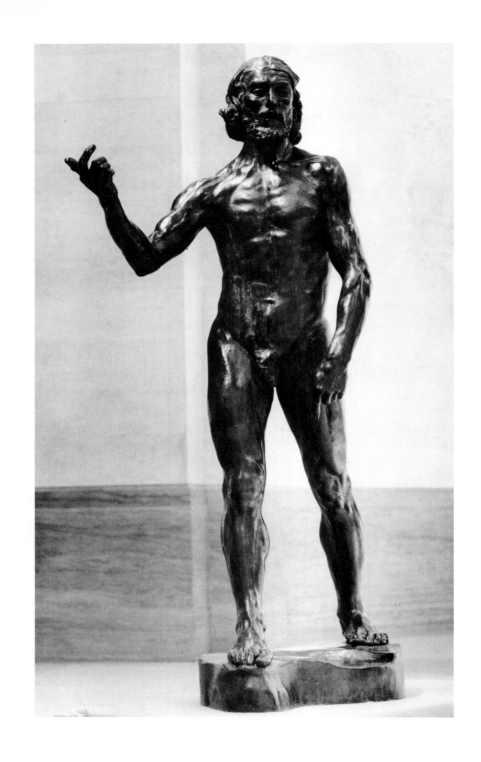

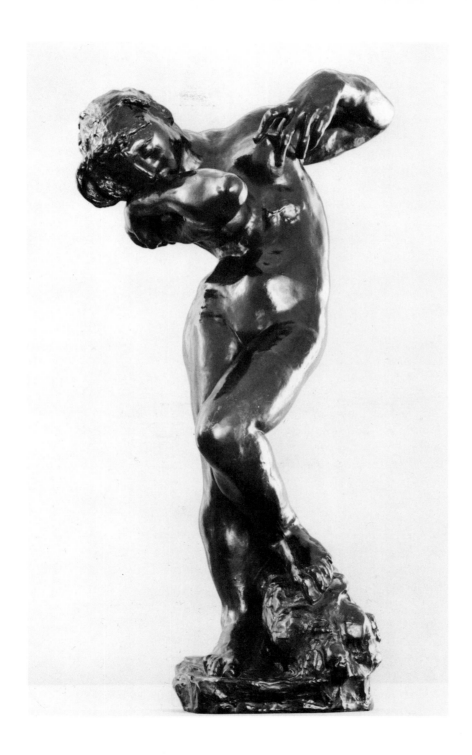

and the Burgher *with the key, like an immense trunk in which purest suffering is held.*

And Eve, bent down as from a distance into her own arms, whose hands, turned outward, seek to ward off everything, even her own changing body.

And the sweet, soft Inner Voice, *armless as inwardness, like an organ liberated from the circulating movement of its group.*

And some small thing, whose name you have forgotten, formed out of a white and shimmering embrace, which holds together like a knot; and that other thing, which is perhaps called Paolo *and* Francesca; *and even smaller ones, which you find within yourselves like fruits with delicate rinds.*

And when you lift your eyes beyond me, like the lenses of a magic lantern, there stands an enormous Balzac *on the wall. The image of a creator in his haughtiness, standing upright in his own movement as in the vortex of a storm, which sweeps up the entire world into his gyring head.*

And now that they are here, shall I set beside these figures from your memory other examples from these hundreds and hundreds of things? This Orpheus, *this* Ugolino, *this* Saint Theresa *receiving the stigmata; this* Victor Hugo, *with his great, oblique, commanding gesture; another version, wholly given over to his whispered promptings; and a third, to whom three maidens' mouths are singing from below, as from a spring that wells out of the earth only for him. And now, while the name is dissipating in my mouth, I sense how all of this is but the Poet, the same poet whose name is* Orpheus *when his arm passes across all things on its great roundabout way to the strings; the same who, cramped and agonized, clutches the fleeing Muse's feet while she is vanishing; the same who finally dies, his face raised upright in the shadow of his voices, which sing into the world still; and so dies that this little group is sometimes also known as* Resurrection.

But who now is able to stem the tide of these lovers, which rises beyond us on the sea of this work? Destinies and sweet and disconsolate names approach us now with these relentlessly linked forms—and then are gone again, like a withdrawing radiance—and one sees the reason why. One sees men and women, men and women, always men and women. And the longer one looks, the more even this content is simplified; and one sees things.

Here my words become powerless, and return to that great insight for which I have already prepared you, the knowledge of the single surface, through which the entire world is offered to this art. Offered, but not yet given. To take it requires (and shall always require) unending labor.

Consider how he who wishes to master all of this surface must labor, because no thing is like another. He, for whom it is not enough to come to know the body in

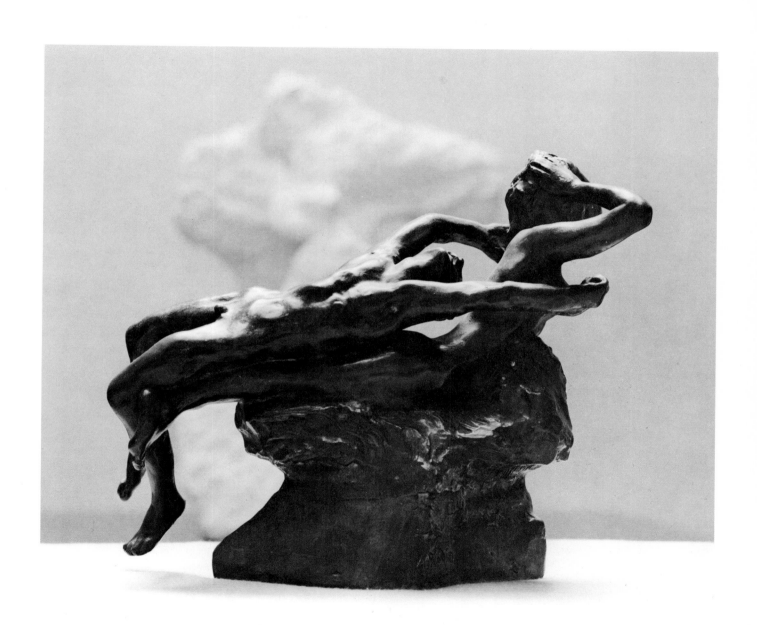

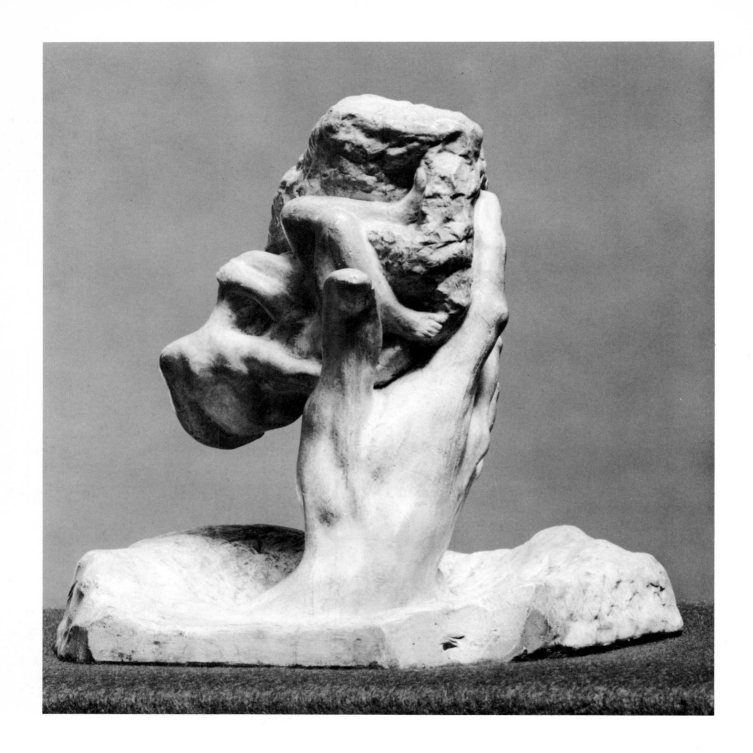

general, the face, the hand (for all of these do not exist), but rather all bodies, all faces, all hands. What an immense task arises there! And how plain and earnest it is, how fully without allure or promise, how fully without pretension.

A handwork is called for, but it seems handwork for an immortal, it is so vast, so devoid of perspective and without end, and so completely dependent on perpetual learning. Where could a patience be found equal to such handwork?

It was found in the love of this worker, and was perpetually renewed there. For that is perhaps the secret of this master: that he was a lover, whom nothing could resist. His desire was so enduring and passionate and uninterrupted that all things yielded to it: the natural things, and all the enigmatic things of all the ages, in which all that was human longed to become nature. He did not linger by those that were easy to admire. He wanted to learn admiration fully, to its end. He took up ponderous and inaccessible things, and bore them, and their burden forced him more and more into his craft. Under their pressure it became clear to him that with things of art, as with a weapon or a balance, it was not a matter of appearing in a certain way, and thus of "working" by means of such appearance, but rather that it was a question of being well made.

This making-well, this working with a clearest conscience, was all. To reproduce a thing: that meant to have gone over every part, concealing nothing, overlooking nothing, deceiving nowhere; to know all of the hundred profiles, all the overviews and underviews, and every point of intersection. Only then was a thing really there, only then was it an island, liberated everywhere from the continent of the uncertain.

This work (the work of modeling) was the same with everything one made; and it must be done so humbly, so submissively, so devotedly, so devoid of choice on face and hand and body, that there was nothing more there that one could name, that one merely made a form without knowing what it was that was coming to be, like a worm that goes his way from place to place in darkness. For who can remain unprejudiced vis-a-vis forms that have a name? Who has not already chosen when he calls something a face? But the creator does not have the right to choose. His labor must be permeated with unvarying obedience. Forms must pass through his fingers like something left unopened, something entrusted to him, that they might remain pure and whole in his work.

And the forms in Rodin's work are pure and whole; without questioning he conveyed them to his things, which seem never to have been touched when he leaves them. Light and shadow pass over them as gently as over the freshest fruit, as animated as if lured there by a morning breeze.

Here we must speak of movement, though not at all in that sense in which it has so often been mentioned as a reproach; for the movement of the gestures, which has been much observed in this sculpture, takes place within these things, like an inner

circulation, never disturbing their calm or the stability of their architecture. Of course, it would have been nothing new to have introduced movement into sculpture. What is new is the kind of movement, movement to which the light is compelled by the particular quality of these surfaces, whose inclines are so variously modulated that it flows slowly here and plunges there, appearing now shallow and now deep, now lustrous and now matt. The light which comes in contact with one of these things is no longer ordinary light; it suffers no further chance alterations. The thing takes possession of it, and uses it as its own property.

This acquisition and appropriation of light as a consequence of defining a surface with perfect clarity was recognized by Rodin to be an essential characteristic of sculpted things. Both antique and gothic art had sought solutions to this problem, each in its own fashion; and he placed himself within this ancient tradition by making the mastery of light a part of his development.

And within his work there are actually stones with their own light, like the face called Thought, bowed over its block in the Luxembourg Museum, which, inclining forward into shadow, hovers above the white shimmer of its stone, in whose reflection all shadows are dispersed and muted to a transparent chiaroscuro. And who can recall without delight that small group in which two bodies create a twilight so that they might softly meet there with a subdued radiance? And isn't it remarkable to see the light pass over the recumbent back of the Danaid, so slowly that it scarcely seems to have made any progress in hours? Was there anyone still acquainted with this whole scale of shadows extending upward to that diffident, thin darkness, which sometimes plays about the navels of small antiques, and which we now only know from curves in the hollows of rose petals?

The progress in Rodin's work consists of such—barely utterable—advances. With the subjugation of light the next great conquest had already begun, that to which his things owe their stature, this magnitude that is independent of all measure. I mean the acquisition of space.

Once again it was things that came to his aid, as so often before, the things outside in nature, and certain things of art of an exalted lineage, which he incessantly returned to interrogate. Each time they repeated a respect for law, by which they were fulfilled and which he gradually came to comprehend. They vouchsafed him a glance into a secret geometry of space, which led him to the insight that the contours of the thing must fall into alignment with certain planes inclined toward one another, in order that the thing be truly taken into space, recognized, so to speak, in all its cosmic self-sufficiency.

It is difficult to express this insight with precision. But we may observe how Rodin applied it in his work. The details at hand are concentrated ever more surely and energetically to unities of surface that finally they take their place, as though under the

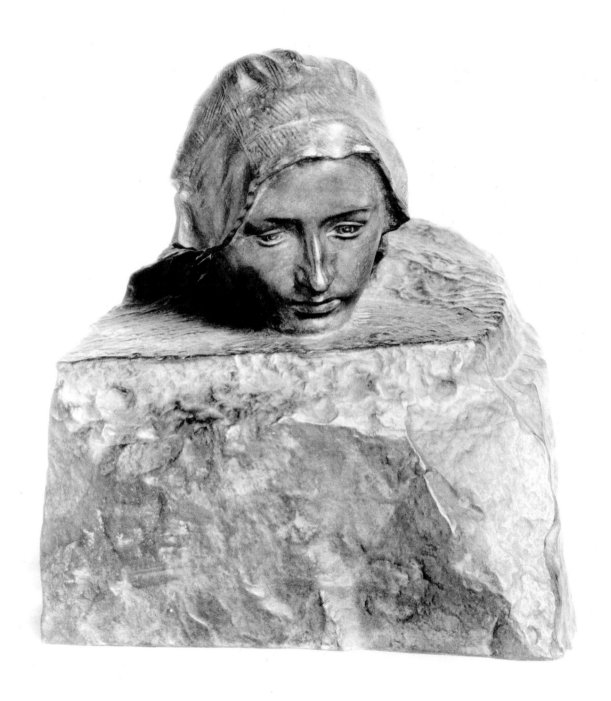

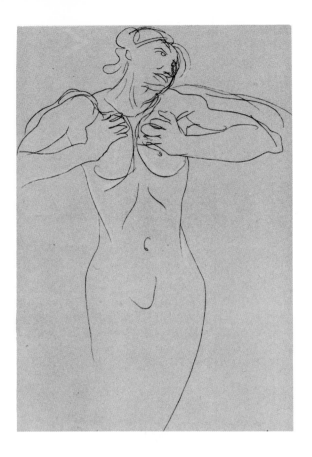

influence of rotating forces, within certain great planes, aligning themselves in such a way that one seems to see how these planes belong to the sphere of heaven, and extend into infinity.

There is The Age of Bronze, *which still stands as if enclosed in an inner space. About St. John the Baptist this begins to fall back from every side; and the entire atmosphere surrounds Balzac. But a couple of headless figures, the incredible new Walking Man, above all, seem to have been set above us, into the universe, among the stars in a vast and unerring revolution.*

As in a fairy-tale, once the gigantic has been overcome, it makes itself small for its conqueror in order to be wholly his; so the master was truly able to take possession of the space won by his things as his own property. For it is whole, in all its immeasurable expanse, in those curious pages which one is always inclined to think must represent the ultimate development of his work. These sketches from the last ten years are not

what so many people take them to be: rapid notations, preparations, preliminary material. They contain the culmination of his long, uninterrupted experience. And they contain this, as by a perpetual miracle, in a void, within a rapid outline, in a contour taken breathlessly from Nature, in the contour of a contour, which she herself seems to have laid aside, because it was too delicate and too precious. Never have there been lines, not even in the rarest Japanese drawings, of such power of expression, which are at the same time so free of purpose. For nothing is represented here, nothing is intended; there is no trace of a name.

And yet, what is not here? What holding or releasing or no longer being able to hold; what inclination, extension and contraction, what falling or flight has one ever seen or intimated that doesn't appear here once again? And if it had ever appeared anywhere, then it had to have been lost; for it was so fine and fleeting, so little meant for anyone, that no one was able to give it a sense. Now for the first time, as one unsuspectingly sees it again in these pages, one knows its meaning: the utmost of love and suffering, of despair and blessedness, emanates from them; and one cannot know why.

There are forms that rise, and their rise is breathtaking, as only a morning can be when it is dispersed by the sun. And there are forms so delicate, which withdraw so rapidly, that their departure fills one with dismay, as though one could not live without them. There are recumbent forms about which sleep and dreams ascend in clusters; inert forms, heavy with torpor, which wait; and depraved forms which can wait no longer. One sees their depravity, and it is like the growth of a plant, which grows in madness because it cannot do otherwise. One perceives how much of the inclination of a flower there is in this inclining form; and that all of this is the world, even this figure, which is enchanted like a constellation in the zodiac, and held fast forever in its passionate solitude.

But when one of these moving forms is seen beneath a little green pigment, then this is the sea or the seafloor, and it moves differently, with greater effort, under water. Or a hint of blue under a falling figure is enough—and space plunges into the page from every side, enclosing it with so much void that one is suddenly seized by vertigo and grasps involuntarily for the master's hand, which is holding out the drawing with a gentle attitude of offering.

Now, I see, I have shown you one of the master's gestures. You desire others. You feel yourselves sufficiently prepared to be able to arrange even external and superficial elements into a whole, that they become the features of a personal image. You desire to hear the wording of a sentence as it was spoken. You wish to enter dates and places on the mountain-and-river chart of this work.

Here is a photograph taken from an oil painting. Indistinctly it shows a young man at the end of the sixties. The simple lines upon the beardless face are almost hard,

but the clear eyes gazing out of shadows unify the individual features to a mild expression of near reverie, such as young men have under the influence of solitude; it is like the face of one who has been reading deep into twilight.

Here is another picture, around 1880. One sees a man stamped by activity. The face has become gaunt; the long beard flows negligently over the broad-shouldered breast, on which the coat has grown too loose. In the faded, ash-yellow tones of the photograph, one seems to perceive that the eyelids are red, but the glance passes resolute and confident out of the overworked eyes, and there is an elastic tension which will not be broken in the bearing.

And suddenly, after a few years, all of that is changed. Something final has evolved from the provisional and the indefinite, something made to endure. All at once the brow is there, "rocky" and steep, from which the straight, strong nose juts forward over nostrils delicate and sensitive. The eyes lie as under a stone arch, far-seeing without and within. The mouth is a faun's mask, half-concealed and enhanced by the sensuous silence of recent centuries; and beneath it the beard, as though too long restrained, plunges forward in a single white cascade. And the figure which bears this head is not to be moved from its place.

And if one must say what emanates from this figure, it is this: that it seems to extend backward like a river god and to gaze forward like a prophet. It is not marked by our time. Strictly delimited in its uniqueness, it nevertheless vanishes into a certain medieval anonymity, possessing that humility of greatness which recalls the builders of the great cathedrals. Its solitude is never isolation, for it rests within its kinship to nature. Its manliness is free of hardness even in obduracy; so that a friend of Rodin, whom he sometimes visited at evening, was able to write: "When he departed there remained a certain mildness in the twilight in the room, as if a woman had been there."

And indeed, the few who have been accepted into the master's friendship have experienced his goodness, which is as elemental as the goodness of a force of nature, like the goodness of a summer day, which brings growth to everything and darkens late. But even the passing visitors of Saturday afternoons have shared in it, when again and again they encounter the master between completed and half-finished works in the two studios at the Dépôt des Marbres. From the first moment on, one feels assured in his politeness, but is almost terrified by the intensity of his interest when he turns towards one. Then he has a gaze of concentrated attention, which comes and goes like the light of a beacon, but is so strong that one feels even the things far behind oneself becoming bright.

You have often heard descriptions of the workshops in the rue de l'Université. These are the cutting sheds in which the stones for these great works are hewn. Almost as inhospitable as stone quarries, they offer no diversion to the visitor; equipped only

Auguste Rodin

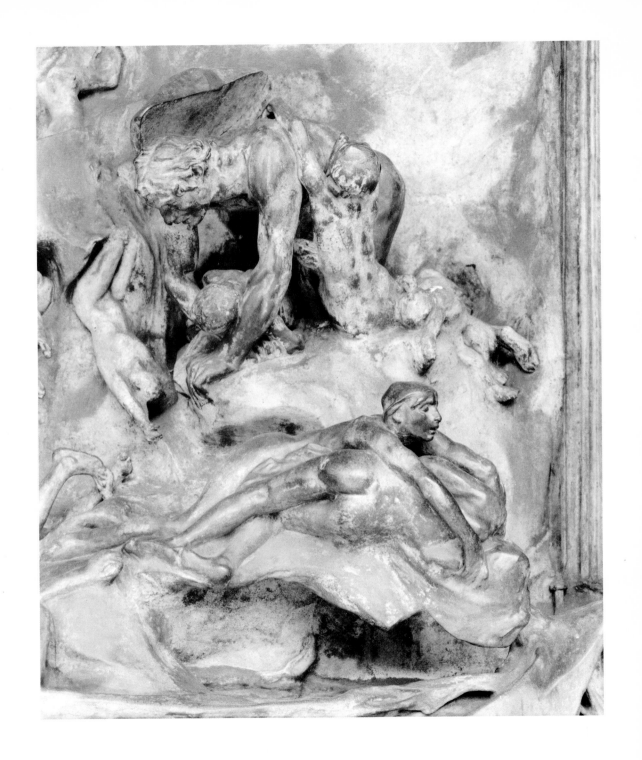

for labor, they compel him to take up the labor of seeing, and many have discovered here for the first time how unaccustomed they are to such labor. Others, who have learned, have departed again with their progress, and have remarked how everything outside has furthered their learning. But these rooms are surely most remarkable for those who can already see. Guided by a sense of gentlest necessity, they come here, often from a great distance, and for them to stand here in the shelter of these things is like something that one day had to happen. It is a culmination and a new beginning, the still fulfillment of their wish that somewhere, among all these words, they might find an example, a simple realization of achievement. And Rodin may well step up to such visitors and admire with them what they are admiring. For the dark way of his purpose-less labor, leading to this handwork, has enabled him to stand in selfless admiration before his completed things, which he has never patronized or controlled, when they are finally there, surpassing him.

And his admiration is always better, more fundamental, more delighted than that of his visitors. His indescribable concentration is everywhere of great benefit to him. And when in conversation, indulgently and with an ironic smile, he shrugs off the imputation of inspiration, and claims that there is no such thing—no inspiration, but rather only labor—then one suddenly comprehends that for this creator receptivity has become so continuous that he no longer feels its coming, because it is no longer ever absent; and one divines the ground of his uninterrupted fruitfulness.

"Avez-vous bien travaillé?"—this is the question with which he greets everyone dear to him; for when that can be answered affirmatively, then there is nothing more to be asked and one can be at peace: whoever works is happy.

For Rodin's simple and integral nature, which has unbelievable stores of energy at its disposal, such a solution was possible; for his genius it was necessary: only thus could it gain mastery of the world. To work as nature works, and not as men; this was always his determination.

Perhaps Sebastian Melmoth felt this, when alone on one of his sad afternoons, he went out to see The Gates of Hell. *Perhaps the hope to begin anew pulsed once again through his half-shattered heart. Perhaps, had it been possible, he would have asked this man, when he was alone with him: How has your life been?*

And Rodin would have answered: Good.

Have you had enemies?

They have not been able to hinder me in my work.

And fame?

Has obligated me to work.

And your friends?

Have desired work from me.

And women?

I have learned to admire them through my work.

But you once were young?

Then I was like anyone. One comprehends nothing when one is young. That comes later, gradually.

What Sebastian Melmoth did not ask has possibly been on the minds of many, when again and again they observed the master, astonished by the enduring power of this near-septuagenarian, by his youth, which has nothing conservative about it, which is as fresh as if it came to him perpetually out of the earth.

And you yourselves ask again, more impatiently: What has his life been like?

If I hesitate to relate it to you chronologically, as histories are usually told, that is because it seems to me as if all the dates that we know (and there are not many of them) are rather general and impersonal in comparison to what this man has made of them. Since all the early events are cut off from us by the impassable mountain range of his mighty work, it is difficult to know the past; we must rely on what the master himself has mentioned on occasion, and on what has been recounted by others.

Of his childhood we have only learned that the boy, when still very young, was sent from Paris to a small pension in Beauvais, where he missed his home, and, tender and delicate, suffered at the hands of those who treated him coldly and without consideration. At the age of fourteen he returned to Paris, and there for the first time became acquainted with clay in a small drawing school. This material appealed to him so greatly that he seemed never to want to let it out of his hands. But he liked everything connected with work; he worked even during his meals: he read and he drew. He drew while he was walking on the streets, and arose very early in the morning to sketch the sleepy animals in the Jardin des Plantes. And where pleasure did not entice him, there he was driven by poverty. Poverty, without which his life had been unthinkable, and which, as he never forgot, had united him with the animals and the flowers, possessionless among the unpossessing, dependent upon God, and only on Him.

When he was seventeen he took employment with a decorator and worked for him, as later for Carrier-Belleuse at the factory in Sèvres and for van Rasbourg in Antwerp and Brussels. His own independent life, vis-a-vis the public, began somewhere around the year 1877. It began with an accusation that he had made the statue The Age of Bronze, which was exhibited at that time, by taking a cast from nature. It began with an accusation. He would scarcely remember that now, were public opinion not so perpetually concerned to accuse and rebuff him. He doesn't complain about it; it is merely that under the influence of such never-waning hostility he has developed a long memory for bad experiences, which otherwise, with his feeling for essentials, he would have allowed to atrophy.

90

His ability was already enormous at that time; as it had been even in the year 1864, when The Man with the Broken Nose *was completed. He had accomplished a great deal in the employment of others, but what there was had been disfigured by other hands, and did not bear his name. Mr. Roger Marx later found and acquired the models which he had executed for Sèvres; they had been broken to fragments and thrown out as useless by the factory. Ten masks, intended for one of the basins at the Trocadero, disappeared soon after they were set in place, and have never been found again. The* Burghers of Calais *was refused the disposition that the master had proposed; no one wished to take part in the unveiling of the monument. In Nancy Rodin was forced to make alterations contrary to his own convictions to the pedestal of the memorial to Claude Lorrain. You may still remember the incredible rejection of* Balzac *by those who had commissioned it, on the grounds that the statue was not a good enough likeness. And perhaps you overlooked it in the papers, but just two years ago the plaster cast of* The Thinker, *erected experimentally before the Panthéon, was destroyed by axe-blows. Nevertheless, it is possible that today or tomorrow you will come across a similar article, in the event that there is another public purchase of one of Rodin's works. For this list, which contains only a selection of the offenses that some seem perpetually to go out of their way to increase, has surely not yet been closed.*

It is conceivable that an artist finally should take up the war repeatedly declared against him—indignation and impatience could have overmastered many—but how far would entering the battlefield have taken him from his work? It is Rodin's triumph that he persevered in his own concerns, and answered this destructiveness after the manner of nature: with a new beginning and tenfold fruitfulness.

Whoever fears to expose himself to a charge of exaggeration would have no means at all to depict Rodin's activity after his return from Belgium. His day began with the sun, but didn't end with it; a long stretch of lamplight was added to its many bright hours. Late at night, when no more models were available, the woman who long had shared his life with touching helpfulness and devotion was always ready to facilitate his labor in his meagre room. She was inconspicuous as his helpmeet, vanishing completely in the many menial tasks that fell to her; but the bust called La Bellone *does not allow us to forget that she could also be beautiful, and the simple later likeness also bears witness to it. And when she at last grew tired, then there was still no need for the laborer to interrupt his work, because his mind was stored with countless memories of forms.*

In those days he laid the foundation for his entire immeasurable work. Almost every piece with which we are acquainted was then begun with a bewildering simultaneity, as though the beginning of their realization was the only guarantee that it would be possible to carry through something so immense. Year after year his surpassing energy continued undiminished; and when a certain exhaustion appeared at last, this was not due so much to his labor, as to the unhealthy conditions which he had too long ignored

in his sunless dwelling in the rue des Grand-Augustins. Admittedly, Rodin had too long often done without nature; for although he sometimes broke away on Sunday afternoons, usually it was already evening before, strolling among the many strollers (since for many years taking an autobus was out of the question), he arrived at the fortifications, beyond which, already indistinct in twilight, the country stretched, just out of reach. But finally it was possible to realize an ancient wish and move upon the land; first to the little cottage in Bellevue, in which Scribe had once dwelled, and later to the heights of Meudon.

There his life became more spacious by far, even though the house (the one-story Villa des Brillants with the high Louis XIII roof) was small and has not since been enlarged. For now there was a garden, which participated with its serene industriousness in everything that took place, and there was distance beyond the windows. What spread out in the new accommodations, and constantly required new additions, was not the master of the house, but rather his beloved things, which now could be pampered. Everything was done for them; just six years ago—you may remember it—he removed the exhibition pavillion from the Pont de l'Alma to Meudon, and gave up that bright and lofty room to his things, which now fill it by the hundreds.

Beside this "Musée Rodin" a personally selected museum of antique statues and fragments has grown piece by piece, containing works of Greek and Egyptian craftsmanship, certain of which would command attention in the chambers of the Louvre. In another room, behind attic vases, there are paintings to which one may assign the correct names without looking for signatures: Ribot, Monet, Carrière, van Gogh, Zuloaga, among others which are less familiar: a couple of these are from Falguière, who was a great painter. It is only natural that there is no lack of dedications: the books alone form an extensive library, one which is curiously autonomous: independent of the choices of its owner, and yet not arranged by chance about him.

All of these objects are surrounded by care and held in honor, but no one expects them to provide atmosphere or comfort. One almost has the feeling that one has never experienced such intense and unhindered individual effects in things of art of the most various kinds and ages as here, where they do not appear full of ambition, as so often in collections, and are also not forced to contribute to a general independent amenity out of the resources of their beauty. Someone once said that they were kept like beautiful animals, and this truly characterizes Rodin's relationship to the things which surround him; for when, often at night, he passes carefully about them, as if not to wake them all, and finally, holding a small light, steps up to an antique marble, which stirs and awakens and suddenly arises, it is life which he has come to find and which he now admires: "La vie, cette merveille," as he once wrote.

There, in the country solitude of his dwelling, he has learned to embrace this life with an ever more believing love. For now it revealed itself to him as to an initiate, hiding nowhere: it had no further mistrust of him. He saw it in the large and in the

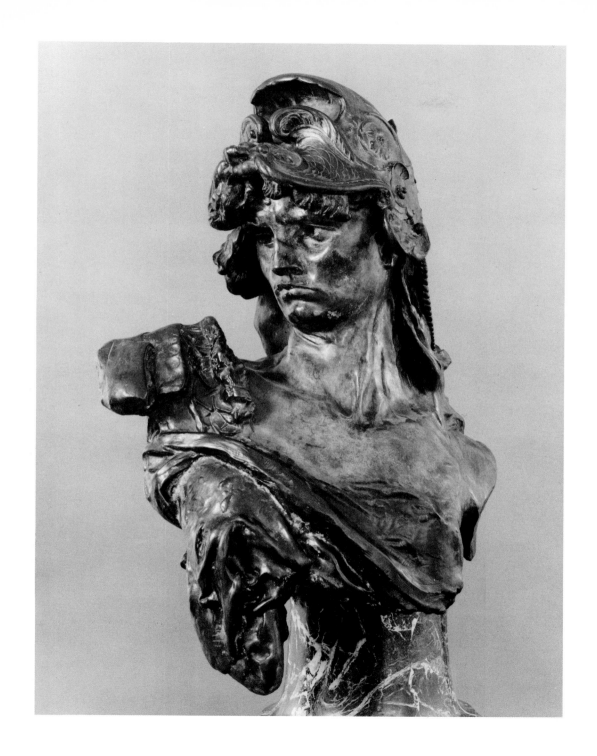

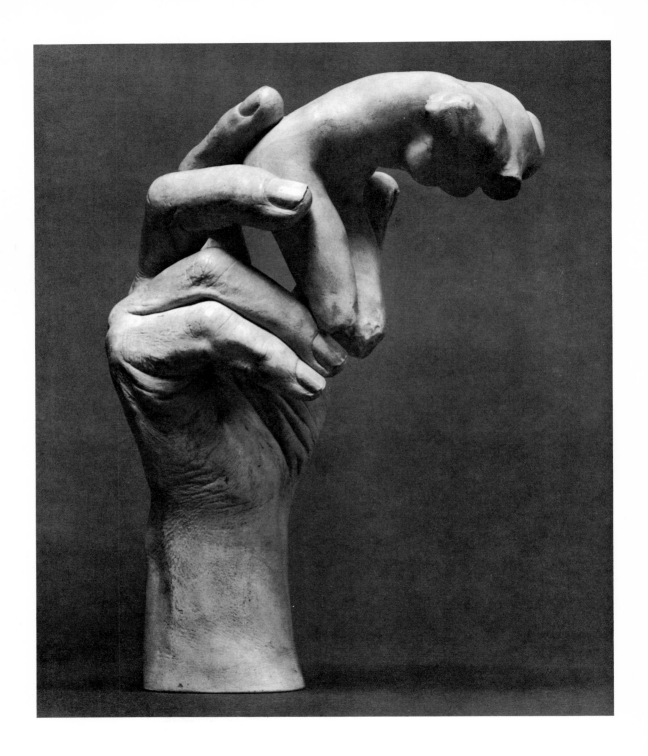

small, in the immeasurable and in the nearly invisible. It is in rising, in going to sleep and in nights of wakefulness. Simple old-fashioned meals are filled with it, the bread and the wine; it is in the joy of dogs, in swans, and in the radiant circlings of doves. It is whole in every tiny flower and hundredfold in every fruit. Any leaf of cabbage from the kitchen garden flaunts it, and with what right! How gladly it glistens in the water, and how happy it is in the trees. And how it takes possession of the life of man, when it can, when he does not resist it. How well the little houses in the distance are arranged, each where it must be, each at its proper elevation. How gloriously the bridge at Sèvres leaps across the river: pausing, resting, gathering itself and again springing, three times. And far beyond, Mont Valèrian, with its fortifications, like a great sculpture, like an Acropolis, like an antique altar. And men have also made things intimate with life: this Apollo, this Buddha resting on the open lotus, this hawk, and this brief torso of a boy, in which there is no lie.

In such insights, continually confirmed for him by everything both near and far, rest the working days of the master of Meudon. And working days they remain, one like the other, except that now this also belongs to the work: this looking into distance, this immersion in everything, this understanding. "Je commence à comprendre," he sometimes says, contemplative and thankful. "And that comes because I have earnestly made an effort to achieve something. Whoever understands one thing, understands all, for the same laws are in everything. I have learned sculpture, and have known well that that was something great. I recall that once when I was reading The Imitation of Christ, *especially in the third book, I replaced the word 'God' everywhere with 'sculpture,' and it worked, and it was right—."*

You smile, and it is right to smile on such an occasion. Its earnestness is so vulnerable that one feels that one must conceal it. But you have already noticed that words like these are not meant to be spoken aloud, as I must speak them here. Perhaps they may fulfill their mission if the individuals who have taken them into themselves endeavor to shape their lives according to them.

In any case, Rodin is silent, like all men of action. He rarely gives himself the right to put his insights into words, because that is the province of the poet, and the poet stands, in his modest estimation, far above the sculptor, who, as he once said with a smile of renunciation, standing before his lovely group The Sculptor and his Muse, *"is so ponderous that he must exert himself indescribably to understand the muse."*

Nevertheless, what has been said of his conversion is true: "quelle impression de bon repas, de nourriture enrichissante"—for behind every word he utters stands, massive and soothing, the simple reality of his experienced days.

You can now understand that these days are full. The mornings pass in Meudon; often several works already begun, in various studios, are taken up one after another, and

each advanced a little. In between business matters obtrude, troublesome and preemptory, whose difficulty and concern are not spared the master, because his works are very rarely handled by the art dealers. Usually around two o'clock a model is waiting in town, either someone who has commissioned a portrait or a professional model; and it is only during the summer that Rodin is able to get back to Meudon before sunset. The evening there is short and always the same, for regularly at nine o'clock everyone is ready for bed.

And if you ask about diversions, about exceptions—strictly speaking, there are none. Renan's "travailler, ça repose" has probably never possessed such daily validity as here. But sometimes nature unexpectedly extends these days, which outwardly seem so alike, and intersperses times, whole holidays, which stretch before the daily work; she does not let her friend lack anything. Mornings wake him with their joyful feeling and he shares with them. He inspects his garden, or he walks to Versailles for the resplendent wakening of the park, as men once journeyed to the levee of a king. He loves the pristine beauty of these early hours. "On voit les animaux et les arbres chez eux," he says cheerfully, and he notices everything that stands rejoicing along the way. He plucks a mushroom, delighted, and shows it to Madame Rodin, who, like him, has not given up these early morning walks. "Look," he says excitedly, "and that takes but a single night. In one night all these are made, all these lamellas. That is good work."

The country landscape extends about the borders of the park. A span of four plowing oxen turns slowly, moving ponderously in the fresh field. Rodin admires their slowness, the thoroughness of what is slow, its abundance. And then: "C'est toute obéissance." His thoughts move like this through his work. He understands this image as he understands the images of poets, with which he occupies himself sometimes at evening. (But no longer with Baudelaire; now and then it is Rousseau, but most often it is with Plato.) But when the horns now blare, raucous and rash, across the peaceful labor in the field from the drilling-grounds at St. Cyr, he smiles—for he sees the shield of Achilles.

And around the next bend the highway lies before him, "la belle route," long and even and like walking itself. For walking is also happiness. His time in Belgium taught him that. Very skillful in his work, and only half-employed by his erstwhile colleague for various reasons, he won whole days which he spent in the country. Of course he carried a paintbox, but it was used ever more rarely, because he perceived that being engrossed with one place would divert him from the joy of a thousand other things, which he as yet knew only meagrely. Thus this became a time of seeing. Rodin called it his richest time. The great beech woods at Soignes, the long bright roads that ran from them toward the vast winds of the plains, the tidy country inns, where rest and mealtime always had something festive about them for all their simplicity (usually there was only bread dipped in wine: "une trempête"). This was long the sphere of his impressions, into which each simple event entered as though accompanied by an angel; for behind each he perceived the wings of a splendor.

Surely he is right to think back on this yearlong walking and seeing with an unequaled thankfulness. It was his preparation for the coming work, its prerequisite in every sense; for it was then that even his health took on that ultimate enduring steadfastness, on which he later so ruthlessly had to count.

Just as he brought back inexhaustible freshness from those years, so he now returns each day from his long morning walks strengthened and eager for work. Joyfully, as if bearing good news, he enters a room where his things are, and steps up to one of them as if he had brought it something beautiful. And in the next moment he is as engrossed as if he had been working there for hours. He begins, and completes, and alters here and there, as though he were going through this throng in answer to the call of those things that most had need of him. Not one is forgotten; those that are thrust into the background wait their hour and have the time. In a garden, likewise, everything does not grow at the same time. Blossoms open beside fruits and certain trees are still just breaking into leaf. Haven't I said that it was the nature of this mighty man to take time like nature, and to bring things forth like her?

I repeat it; and it still always seems wonderful to me that there has been a man whose work has developed to such abundance. But I cannot yet forget the frightened look which checked me once, when, among a small group of people, I used this expression to call up in one moment the full magnitude of Rodin's genius. One day I understood that look.

I was walking lost in thought through that vast workshop, and I saw that everything was in the process of becoming and that nothing was in a hurry. There stood The Thinker in bronze, gigantically compressed into himself, which now was finished, but belonged within the ever-growing circle of The Gates of Hell. And there one monument for Victor Hugo was progressing slowly, possibly subject to further alterations, and beyond stood other versions of it, likewise developing. There, like the unearthed root-system of an ancient oak, lay the group called Ugolino, waiting. And waiting also was that remarkable monument for Puvis de Chavannes, with the table, the apple tree and the glorious genius of eternal peace. That figure over there would be a monument for Whistler, and this resting form might some day make the grave of an unknown person famous. It was almost too much to get through, but finally once again I stood before the small plaster model of The Tower of Labor, whose final configuration now only awaited someone to commission it, someone who would help to erect the vast display of its images among men.

But there was another thing beside me, a silent face to which a suffering hand belonged, and its plaster had that translucent whiteness which things assume only under Rodin's chisel. On its base a legend could be read, scrawled provisionally and then crossed out again: Convalescent. *And then I found myself among nothing but new and namelessly evolving things; they were begun yesterday or the day before yesterday or*

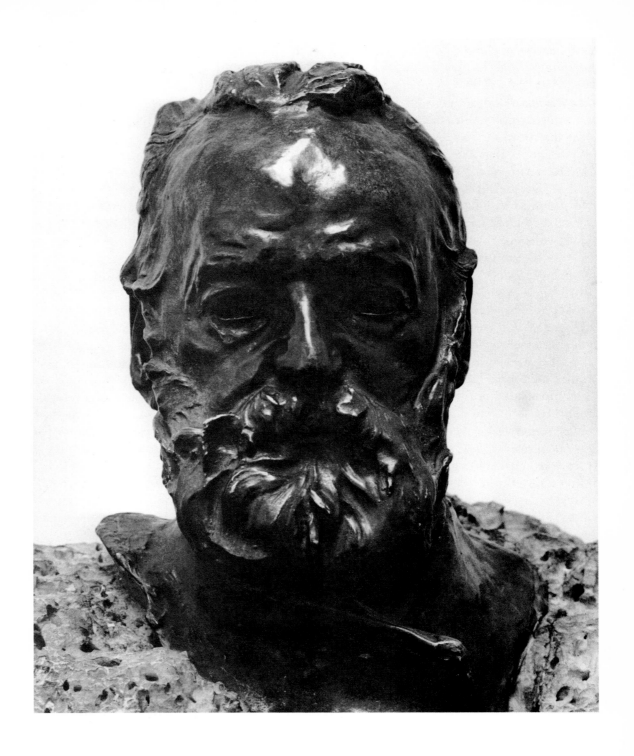

years ago; but they all had the same lightheartedness as the others. They kept no track of time.

And then, for the first time, I asked myself: How is it possible that they do not keep track of time? Why is this great work still rising, and where is it rising to? Does it no longer think of its master? Does it really believe that it is in the hands of nature, like the rocks, for whom a thousand years pass as a single day?

And it seemed to me, in my bewilderment, as though everything finished had to be cleared from the workshop, in order to be able to see what had to be done in the coming years. But while I was counting the many completed figures, the shimmering stones, the bronzes, all these busts, my eye was caught up high upon the form of Balzac, which had returned, rejected, and now stood there haughtily, as though it wished never to leave again.

And since that day I see the tragedy of this work as a consequence of its greatness. I feel more distinctly than ever that in these things sculpture has grown inexorably to a power that it has not known since antiquity. But this sculpture has been born in an age which has no things, no houses, nothing outward. For the inwardness which constitutes this age is without form, ungraspable: it flows.

Yet this man had to grasp it: in his heart he was one who brings forth form. He seized all that was vague and changing and becoming, which was also in himself, and encompassed it and raised it like a god; for even change has a god. It was as though a man had stemmed a rush of molten metal and let it harden in his hands.

Perhaps a part of the opposition which this work engenders everywhere is explained by the fact that in it force came into play. Genius is always terrible for its own age; and in so far as here something perpetually surpassed all that we are, not only in spirit but also in realization, it appeared frightful, like a sign out of heaven.

One is almost persuaded: nowhere shall these things find their place. For who should dare to take them in?

And do they not themselves confess their tragedy, in that they have seized the heavens radiantly to themselves in their abandonment? In that they now stand free, not to be tamed by any building? They stand in space. What have they to do with us?

Imagine that a mountain rose up in a camp of nomads. They would abandon it and move away for the sake of their herds.

And we are a nomadic people, all of us. Not because no one has a home, but because we no longer have a common home. Because we must always carry our greatness about with us, instead of setting it down from time to time in the resting-places of greatness.

And yet whenever something human becomes great, it desires to bury its face in the lap of a universal and nameless greatness. When, for the first time since antiquity, it

last grew into statues, out of men who were themselves in transit, themselves full of transformation—how it then rushed toward the cathedrals and withdrew into the vestibules and climbed the gates and towers as if to escape a flood.

But where are Rodin's things to go?

Eugène Carrière once wrote of him: "Il n'a pas pu collaborer à la cathédrale absente."

There was no place where he could work with others, and no one has worked with him.

With sorrow he saw in the houses and orderly parks of the eighteenth century the last vision of an age's innerworld. And in this vision he patiently discovered the traces of a bond with nature which has since been lost. Ever more unconditionally he drew attention to it, and counseled a return "à l'oeuvre même de Dieu, oeuvre immortelle et redevenue inconnue." And it was meant for them who would come after him, when standing before the landscape he once said: "Voilà tous les styles futures."

His things could not wait; they had to be made. He had long foreseen their homelessness. His only choice was either to let them suffocate within him or to win for them the heaven that surrounds the mountains.

And that was his work.

In a gigantic arc he raised his world above us, and gave it up to nature.

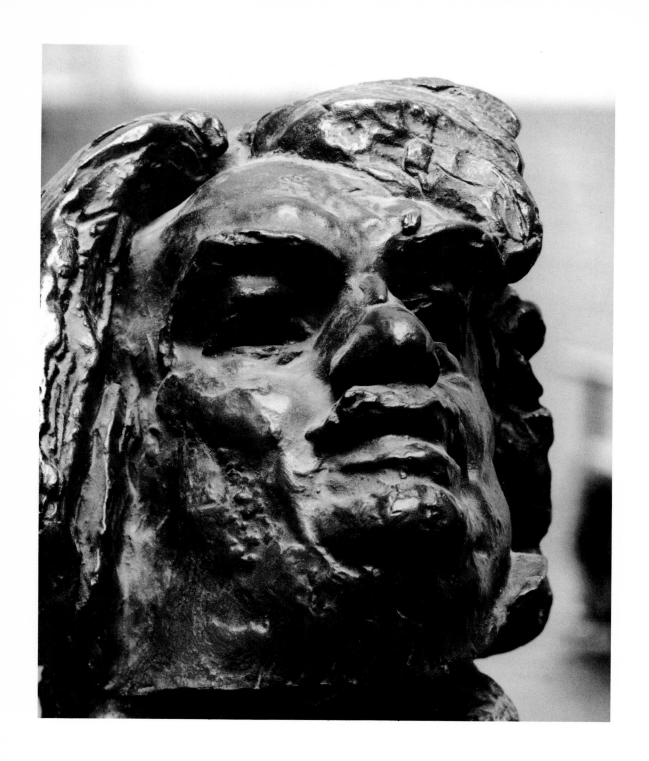

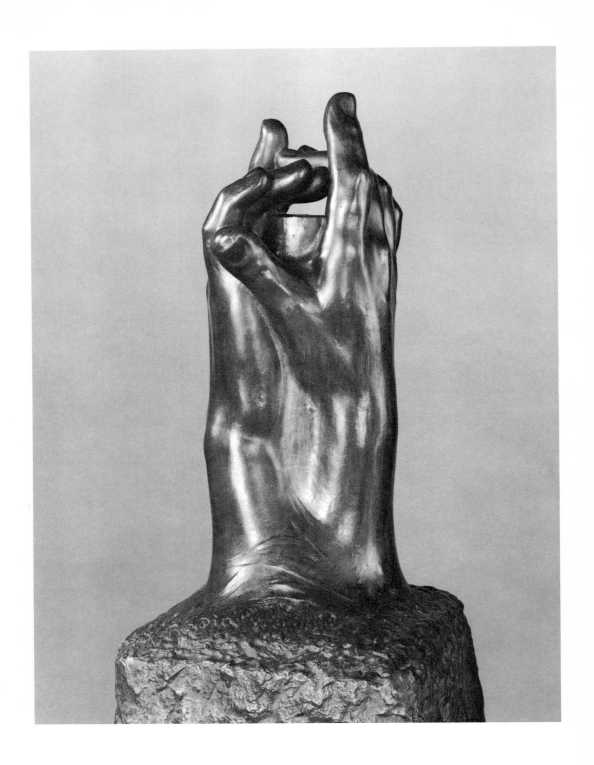

ILLUSTRATION CREDITS